DIGITAL MANGA
COMPOSITION & PERSPECTIVE

A Guide for Comic Book Artists

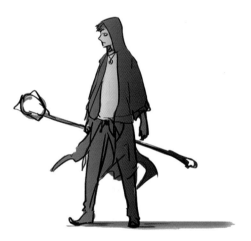

Rui Tomono
Studio Hard Deluxe

TUTTLE Publishing
Tokyo | Rutland, Vermont | Singapore

Contents

Studying Photographs: Types of Composition

When explaining about composition, photography always comes into the conversation. Recently, the composition theory that has become established in the photography world is being used to create illustrations too.

While reading through the explanations from Chapter 2 onward, if you are having issues with your composition, please refer to this section.

Bisection

The simpler something is, the deeper it becomes...
Composition is the same!

Difficulty	★ ★ ★ ★ ☆
Landscape/ Background	★ ★ ☆ ☆ ☆
Characters	★ ★ ★ ☆ ☆
Scene Depiction	★ ★ ★ ★ ★

Application Notes
▶ Useful when contrasting two things
▶ Used to emphasize the relationship between the foreground and background (or left and right sides)
▶ Useful for expressing unique scenery and landscapes

The Features of This Composition

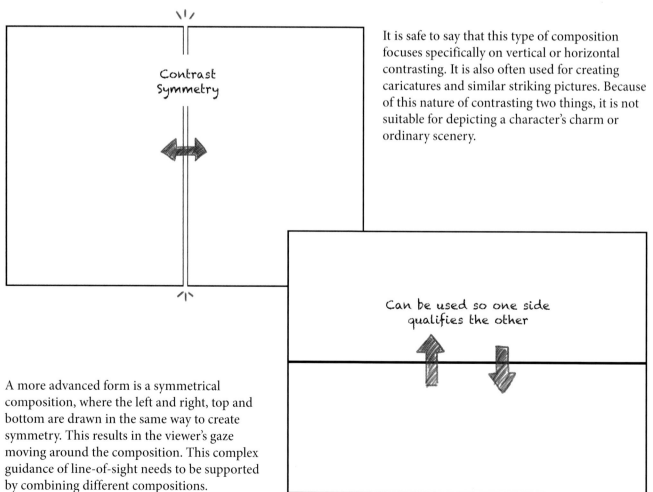

Contrast
Symmetry

Can be used so one side
qualifies the other

It is safe to say that this type of composition focuses specifically on vertical or horizontal contrasting. It is also often used for creating caricatures and similar striking pictures. Because of this nature of contrasting two things, it is not suitable for depicting a character's charm or ordinary scenery.

A more advanced form is a symmetrical composition, where the left and right, top and bottom are drawn in the same way to create symmetry. This results in the viewer's gaze moving around the composition. This complex guidance of line-of-sight needs to be supported by combining different compositions.

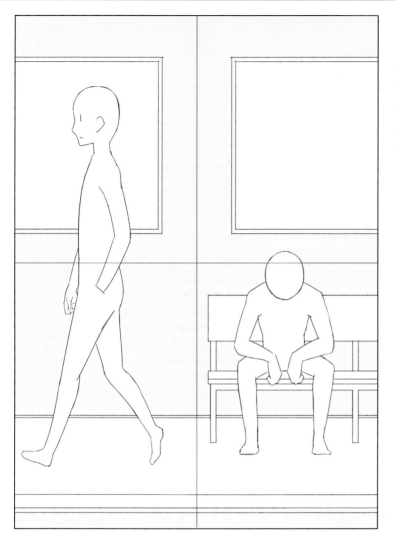

Example 1

Here is an example of a striking scene. We can see a person walking in the left frame, while someone is sitting down in the right frame. This illustrates a contrast of the concepts of advancement and stagnation. It could be made more effective by adding a message to the poster in the background.

Example 2

A symmetrical composition can be used to express a mirror world. Uyuni Salt Flat in Bolivia is the most famous example of a natural environment that produces this effect. If you draw a person in the lower half of the composition who appears different from the individual in the upper half, this contrast can be used to express that person's past or relationships. You can convey duality by giving the person different facial expressions and poses in the reflected imagery.

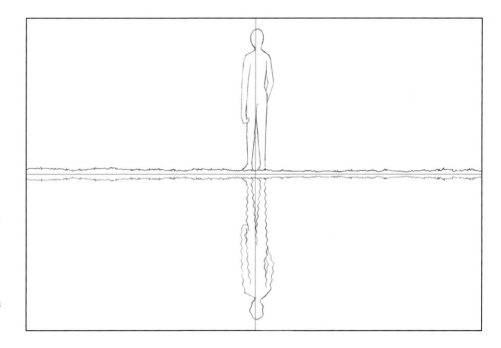

The Rule of Thirds

Not sure about the composition? Having trouble getting a balanced background?
This is composition is perfect for beginners!

Difficulty	★ ☆ ☆ ☆ ☆
Landscape/Background	★ ★ ★ ★ ★
Characters	★ ★ ★ ★ ★
Scene Depiction	★ ★ ★ ★ ★

Application Notes
▶ Can be used in a wide range of situations
▶ Helpful when roughing out initial ideas
▶ Ideal for when there are many elements to arrange

The Features of This Composition

This is the most practical composition, dividing the picture into 3 vertical sections and 3 horizontal sections. The only drawback is that because it is so adaptable, it is difficult to know where to start when adding content. Along with providing structure for expressing perspective and contrast, it also helps you manage the density of your composition. While creating a rough sketch, if you feel something doesn't look right, you may want to first try drawing reference lines to divide your composition into thirds.

The point where a vertical and horizontal line intersect is commonly known as a "power point." This point of intersection also acts as a reference point for placing elements.

Using this rule of thirds composition is an excellent way to ensure the elements fit and are well presented. That said, dividing everything into thirds is not advisable. Sometimes it's important to have unbalanced parts in a picture. These elements can be attractive too. As will be seen in Example 2 on the facing page, straight lines prevent the viewer's gaze from being drawn to the image. Take time to analyze what will look best and carefully consider what to prioritize.

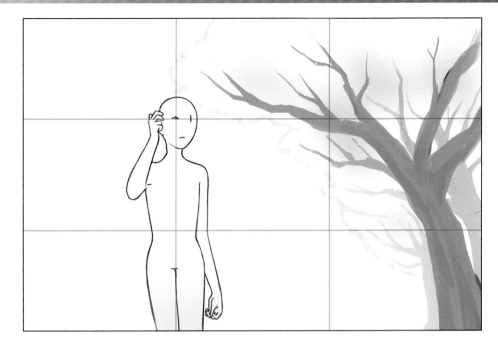

Example 1

The person has been placed on the left-side reference line and the trees placed in the whole right-side section and in the top center. Here, I have made it so the person has one eye closed to give the impression that they suspect something may soon occur on their walk. The trees are used to express depth. From here, I want to place elements that fill in the surrounding space and draw more attention to the person.

Example 2

This is unorthodox, but in order to give an example of a three-by-three grid composition, here the horizon and the top of the embankment run along the reference lines.

(This is not a recommended use, as it forms too regular and monotonous an image, with the parallel lines discouraging the movement of the eyes around the composition.)

A person is standing on the top of an embankment. We could imagine that this is an older person. They are watching the sunset over the sea and maybe reflecting on their life. How would the impression change if the sunset were brighter or if there were a boat floating on the ocean?

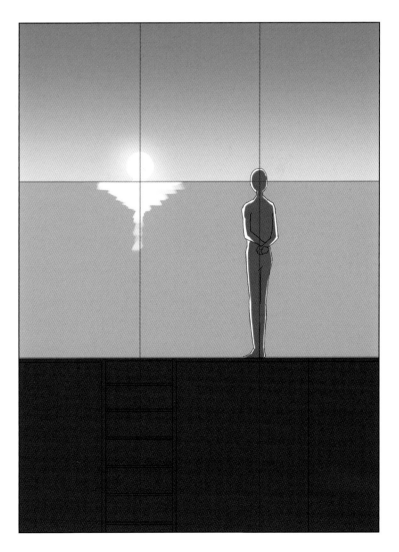

The Golden Ratio

While there is no real proof of this being effective, it is still highly recommended!

Difficulty	★	★	★	☆	☆
Landscape/ Background	★	★	★	☆	☆
Characters	★	★	★	☆	☆
Scene Depiction	★	★	★	☆	☆

Application Notes
▶ Useful for creating a complex composition
▶ Useful for creating a pleasing impression
▶ Ideal if you believe in the efficacy of the golden ratio!

The Features of This Composition

This type of golden ratio is also called the "divine proportion." There is no way to prove that the golden ratio itself is "beautiful." Due to this, the way it works is still not well understood. In fact, articles that describe the golden ratio provide little insight on how it is constructed and many contain incorrect information.

It's true though that the majority of pictures that make viewers think "there's something good about this" use this golden ratio. This "je ne sais quoi" is more important than you might think, so never underestimate it.

For the composition itself, first draw diagonal lines in a golden ratio rectangle that has an aspect ratio of 1:1.618 (approximately). The actual golden ratio division is created by drawing further lines from the remaining corners, forming right angles to the first diagonal lines. When divided in this way, all the ratios become approximately 1:1.618, as shown in the above right figure. Place this in the drawing window and maximize it, while maintaining the aspect ratio.

This type of drawing, aligning with these reference lines, is best avoided by beginners. There are many points of intersection, making placing the elements challenging.

Incidentally, another type of golden ratio (see page 60) where the reference lines are drawn from the points where the sides are divided by 1:1.618 (approx.) is different in nature to this golden ratio. This is good to use when you don't want to have such clear division as in the bisectional composition or want to use intentionally unbalanced parts as a standard, shifting away from a rule-of-thirds composition.

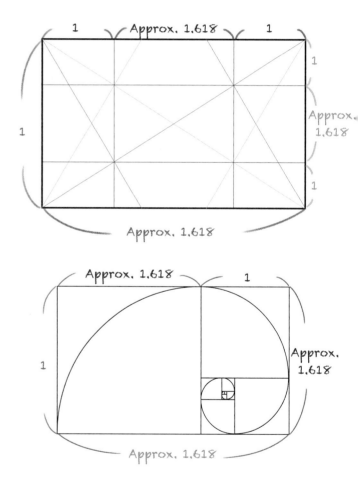

You can also often see the spiral-like composition style shown in the figure above. It is particularly used in design and photography. The curved lines are circles that have been drawn from the corners of the squares and joined together. The elements are placed within the curved lines. Further, this composition is considered beautiful as its flow guides the viewer's gaze into the center of the spiral.

Example 1

The elements are placed along the blue reference lines. This is a high-angle view (seen from above), so if the perspective is accurate, the people's heads should be tilting outward. When looked at as a perspective drawing, it forms a different expression.

The wall is on the diagonal line of the golden ratio. The left person's foot is placed at a point of intersection ("power point"). The viewer's gaze is easily drawn toward the movement of that figure on the left.

Example 2

The golden ratio is also useful for portraits and landscapes. In this portrait, the face and bouquet of flowers are both placed so they are framed by the reference lines. It is a good idea to place elements around them and set imaginary lines (paths to guide the viewer's gaze) that run through the center.

Imaginary Lines

These are also called implied lines. These include lines that extend from the shape of an element, the gaze of a person, or the direction of motion (orientation). They are pathways through which the elements have the power to draw the viewer's gaze. They can also be lines that describe the path that gaze will take. Have them converging in from all around the picture to the focal point, so that the viewer's gaze is guided to the part you most want them to fixate on. It's preferable to then have their gaze move on around the image from there.

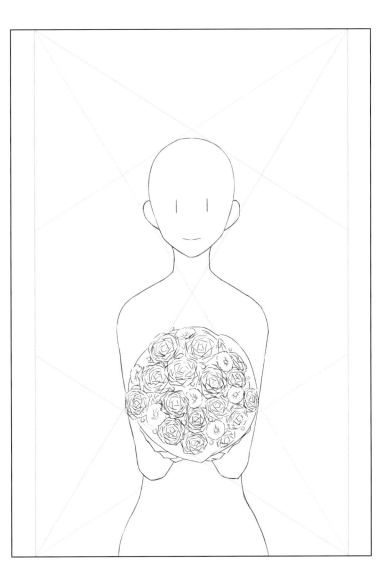

Central Circular Compositions (Hinomaru)

Wanting to showcase only the main character?
This is the composition to try!

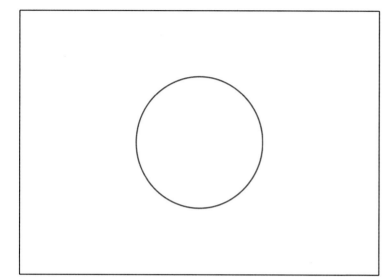

Difficulty	★ ★ ★ ★ ★
Landscape/ Background	★ ☆ ☆ ☆ ☆
Characters	★ ★ ☆ ☆ ☆
Scene Depiction	★ ★ ★ ☆ ☆

Application Notes
▶ Useful for when you want to have only the main character to stand out and nothing else
▶ Place text and information in the surrounding area

The Features of This Composition

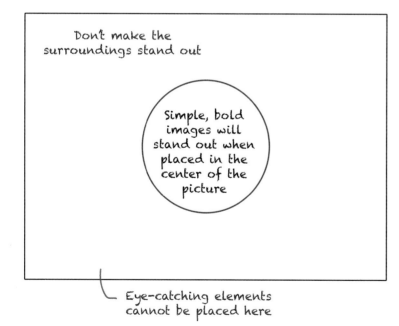

Don't make the surroundings stand out

Simple, bold images will stand out when placed in the center of the picture

Eye-catching elements cannot be placed here

This composition resembles the Japanese flag, the Hinomaru, which is why it is so named. It has a high degree of difficulty, with its purpose being to draw attention to the main character placed in the center, while making sure none of the surrounding elements stand out.

Some photographers consider this a bad composition. But in general, there is nothing wrong with circular composition. There is a great deal of thoughtful decision-making involved, making effective execution a challenge. You need to intentionally reduce the level of attention drawn by the elements surrounding the central focus.

This is an advanced technique, so it can be challenging for beginners who have just started drawing backgrounds. Nevertheless, give it a try!

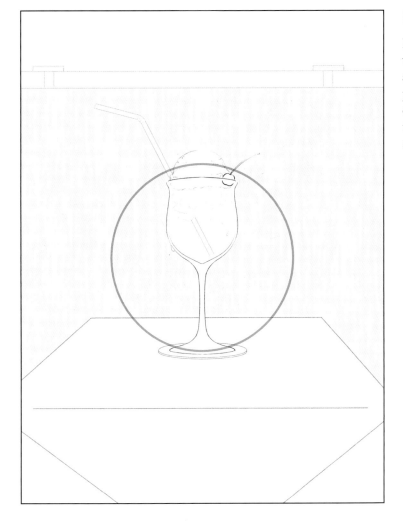

Example 1

Here, a cream soda has been placed in the center, with the assumption that a logo and text will be arranged around it. A Gaussian blur has been applied to the background so as to reduce the detail of the wood grain and the brightness increased to make it fainter. This gives it a similar impression to a photo taken using a macro lens.

Example 2

Here, in reverse, a door has been placed in the center of a wood-paneled wall. The door has been made brighter than its surroundings, creating a contrast with the darker background. The image has been darkened radially, using gradation to reduce the brightness toward the edges. This effectively draws the viewer's gaze toward the center.

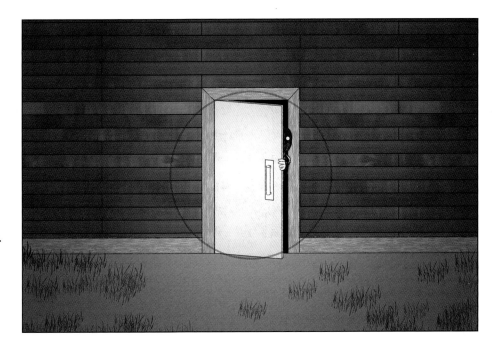

Framing Compositions

This technique is an attractive way to naturally guide the viewer's gaze and add depth. It's ideal for creating atmospheric compositions!

Difficulty	★ ★ ☆ ☆ ☆
Landscape/Background	★ ★ ★ ★ ★
Characters	★ ★ ☆ ☆ ☆
Scene Depiction	★ ★ ★ ★ ☆

Application Notes
▶ Use to express a sense of openness
▶ This technique creates a contrast that is not a bisectional composition

The Features of This Composition

Use the frame as a device to easily direct the viewer's gaze

This composition is like the picture frame of a photograph. That is why it is so named. Its advantage is in the way it creates a boundary around the edge of the picture and depth that extends into the background. The dimensions and positioning of the frame affect the area of focus and the extent to which the viewer's gaze is drawn in. This is different from the perspective in the actual image, so it gives an unusual sense of depth.

Easily heightens focus

The frame guides the viewer's gaze to the focal point

The three-dimensionality is palpable as the frame shifts from being broad to narrow. This is the power of linear perspective in action. Even if there are no perspective cues in the framed section, the viewer will be able to observe this effect.

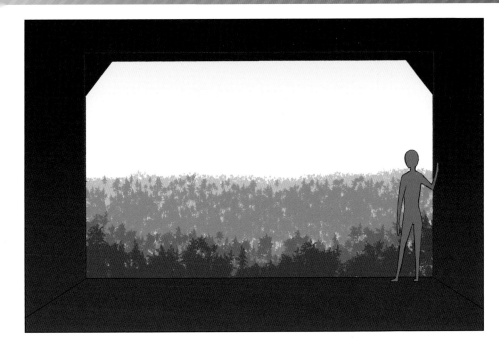

Example 1

This is a view looking out from an angular, tunnel-like structure. In the background, I have drawn the scene of a broad forest stretching out into the distance.

The structure is artificial. In other words, the scene contrasts the natural world and an artificially constructed one. Adding in more details to the forest and placing ruins and a townscape farther beyond can create an even more interesting composition.

Example 2

I've created a frame using the alley, shadows, and hanging laundry. The shadowed areas give a feeling of confinement, making the townscape in the distance appear more open. It also contrasts the relative poverty of the surroundings in the foreground with the more affluent environs in the distance.

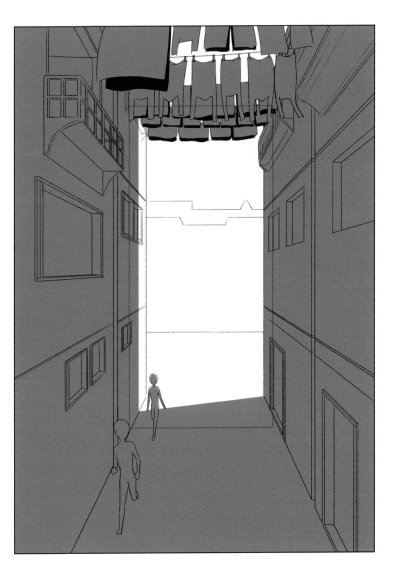

Triangular Compositions

Triangles come to the rescue when you're stuck!
They can be applied in many ways.

Difficulty	★ ★ ★ ☆ ☆
Landscape/ Background	★ ★ ★ ★ ☆
Characters	★ ★ ★ ★ ☆
Scene Depiction	★ ★ ★ ★ ☆

Application Notes
▶ Utilizes the triangular composition's strong gaze-guiding capability
▶ Breaks up the balance in the picture
▶ Produces directionality in the image

The Features of This Composition

The Amazing Properties of a Triangle

① The stability or instability of an object is immediately apparent!

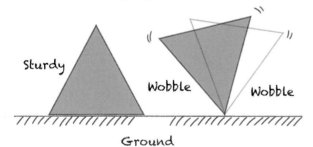

Sturdy

Wobble Wobble

Ground

② Great for guiding the eye

③ Conveys directionality in the composition

The points of the triangle indicate the direction

Triangular composition is roughly comparable to the rule-of-thirds composition in terms of versatility. Make use of it by simply placing elements along the reference lines or positioning them at the corners. That's it! It can guide the viewer's gaze from the surrounding elements and create depth. The key is coming up with ideas that create synergy.

Example 1

The perspective of the stairs matches the placement of a stable triangular form. It has created an upward directionality. This is a basic way to use the triangular composition. At the tip of the triangle is a torii shrine gate, so the viewer's gaze is drawn toward it.

Example 2

Here, I've used an unstable, inverted triangular form. It highlights the person's precariously balanced pose.

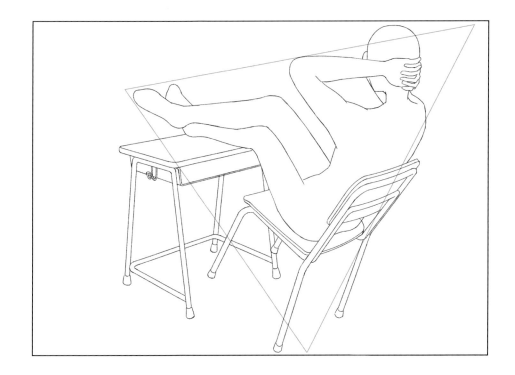

Circular and Semi-Circular Compositions

A curved line cutting across a square screen creates a sense of flow in the space.

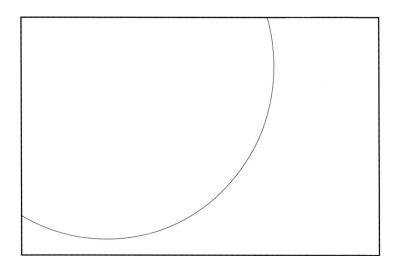

Difficulty	★	★	★	★	☆
Landscape/Background	★	★	★	★	☆
Characters	★	★	☆	☆	☆
Scene Depiction	★	★	★	★	★

Application Notes
▶ Use to express softness
▶ Use to gently guide the gaze

The Features of This Composition

★ Take advantage of curve characteristics

★ Circles and spheres rotate

The gaze follows the rotation

• The flow is created by the curved lines

Hitting invisible walls—the viewer's gaze momentarily pauses at sharp corners

The arrows are where the speed slows down, then picks up again, creating a tempo

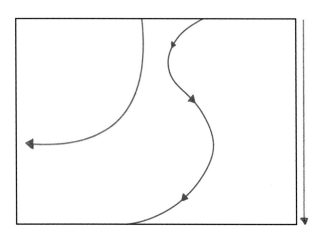

The figure to the left shows compositional curves drawn in the image to create a visual flow. A straight line has a direct forward flow, while a curved line gently moves the gaze along. There is a more advanced form called the S-curve composition. The effect is the same. Elements are placed inside the arc of a curve, with the intent to gradually guide the viewer's gaze and create a flowing impression.

The flow moves from top to bottom

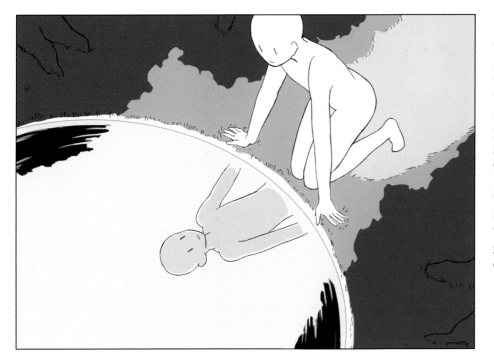

Example 1

There is a curve in the bottom section of the picture and if we apply some visual cues, it takes on the appearance of a reflecting pond. The important point here is that the viewer's gaze is guided toward the elements placed inside the arc. In the illustration on the left, the gaze goes first to the image reflected on the surface of the water. From there, the gaze is guided by the reflection's line of sight toward the person.

Example 2

This picture depicts a scene where a ball is suspended in the air. The sphere is depicted as it would be in a photograph, giving the impression of portraying a still frame from a video clip. The direction of the ball's rotation is toward the person, so the viewer's gaze is guided back and forth between the person and the ball.

Think About Combining Composition Techniques

While each composition can be used solo, it is often more effective to combine them.

Character Illustrations Using the Rule of Thirds + a Circular or Semi-Circular Composition

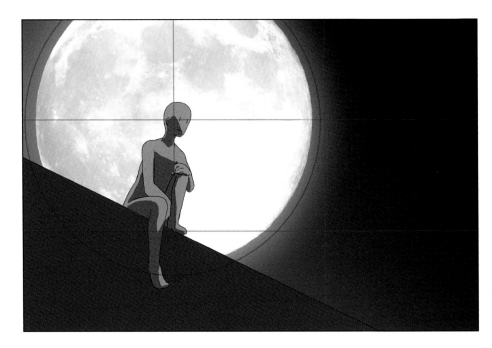

The face of the person is placed at one of the intersection "power points" in the rule of thirds composition, and a huge sphere, the moon, has been drawn in the background. The face is both within the sphere and at an intersection point. The face, accented by the contrast created by the brightness of the moon, is very striking. It would be good to add an element that captures the gaze being pulled down from the moon onto the building to lift it back up again.

Concept Art in a Framing Composition + a Triangular Composition

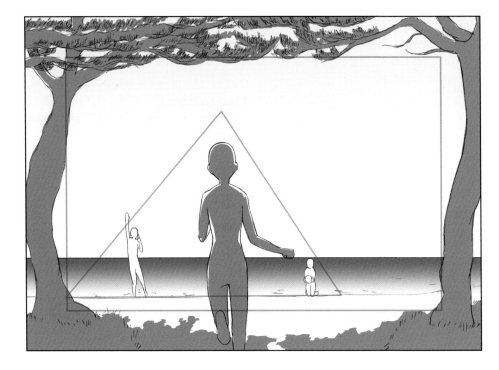

Here, a frame has been formed with pine trunks and branches. Within it, three people have been placed in a triangular formation. The person in the foreground of the picture is running toward the background. The combination of the contrast of the lighting and directionality of the triangle creates a stronger impression and gives a sense of momentum. The sense of openness from the sea visible beyond the pine forest is a motif that complements the people's excitement, which is evident in their body language.

Depicting a Scene Using a Bisectional Composition + a Triangular Composition

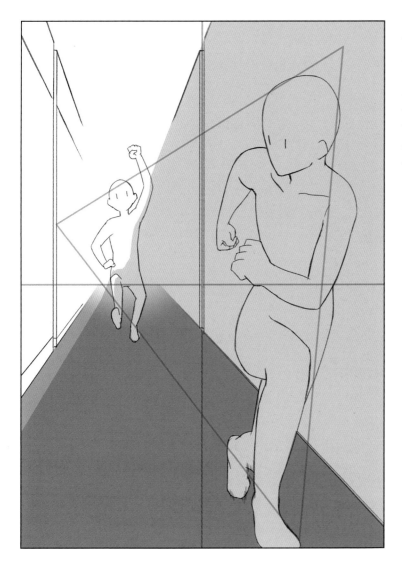

This uses single-point perspective, with the building and path superimposing the lines of perspective. Due to this, the viewer's gaze focuses on the person on the left. But the person on the right is running toward the viewer's vantage point in the foreground, causing the viewer's gaze to move back and forth. There is also a tonal contrast between the person running away and the person who is chasing them.

Depicting a Scene Using a Golden Ratio Composition + a Semi-Circular Composition

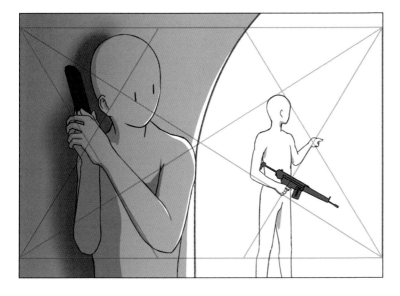

The face of the person in the foreground is placed at the top left point of intersection and the person in the background is placed within an angular frame. A curved line, like that of a tunnel or arched bridge, has been drawn to form a boundary between the two people. This conveys a contrast between calmness and tension.

The line of sight of the person in the foreground and the effect of the curved line guide the viewer's gaze toward the person in the background. Attention-drawing objects, such as a hand or a gun, have also been placed at intersection points. Ultimately, other elements can be placed behind the person in the background. It would then be good to include a way to guide the viewer's gaze to the person in the foreground.

Perspective is a Tool

NOTE

When composition is mentioned in conventional technique books, there is always an explanation about perspective. In fact though, it is not really relevant when creating a composition. It does of course matter a lot in terms of the sense of depth and the consistency in the angle of view. But that is about "correctness." When aiming to gain attention and guide the viewer's gaze, the key to composition is arranging the elements and making them stand out.

You should study perspective in order to eliminate the sense of incongruity that can prevent the viewer's gaze from being guided. In that case, it is very significant. There are many books available that focus on techniques for perspective that you can refer to. What is needed in a composition and what can be safely ignored? Carefully consider the requirements for your own illustrations and what issues are present.

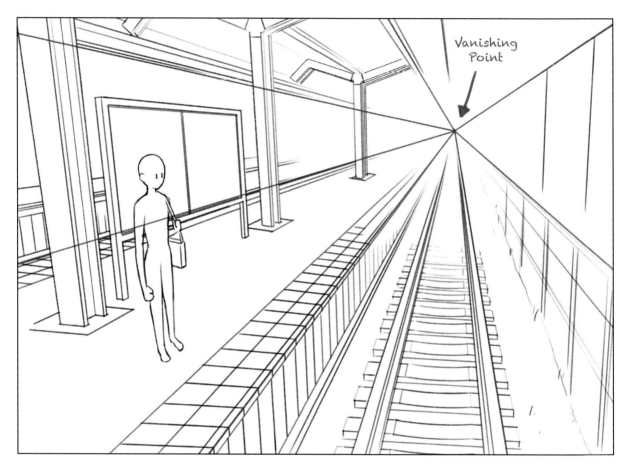

Vanishing Point

This image uses single-point perspective, known in the world of photography as radial composition. Unlike the station in the picture above, most platforms do not run straight as far as the eye can see.

In regard to the composition, elements such as the placement of the person and the arriving train are connected. Perspective is simply a "standard of realism." In other words, it is a tool, so there is no need to strictly adhere to it. As long as the viewer is not distracted by a sense of unintended strangeness, it is fine.

Compositions with a Person as the Main Element

The basic principle of a composition is to convey a message to the person looking at the picture. What should stand out and what should not? I have compiled my own techniques for composing illustrations, having studied the fundamentals of art, and will explain them in the following pages.

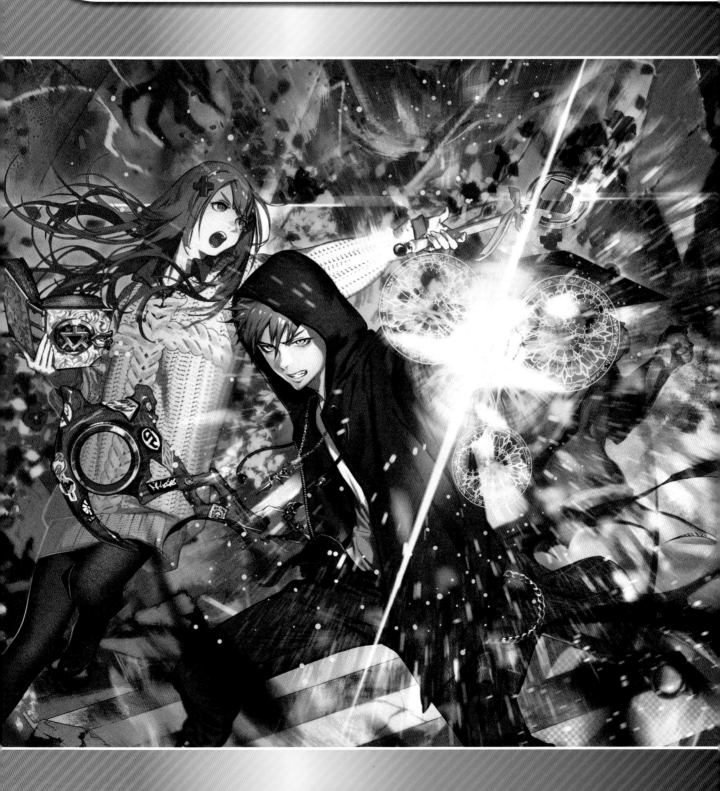

Explanation of the Color Illustrations

Motivation for Creating Compositions

Say you are drawing a picture of an idealized character, but you feel it doesn't look cute or cool enough. You then go through the trial-and-error of making the eyes slightly bigger or the muscles a little thicker, right? I think this sort of fine-tuning extends to the subject of composition, as well.

For instance, you may want to indicate the relationship between a protagonist and a rival, or depict a magnificent castle. You might think, "I'll position the protagonist in the sunlight, and the rival in the shadows," or "To show its size, I'll juxtapose a person in front." This creative process of improvement and fine-tuning is precisely what composition is all about. It's similar to the kind of trial-and-error you undertake when finessing your drawing of an idealized character.

When you have something you're keen to draw, the composition considerations are naturally your second priority. From this section onward, we won't be focusing on matching a picture to a format that gives conventional compositional methods precedence. Instead, we will look at composition related to how a picture changes according to the world you want to draw.

When I created the illustrations for this book, I started by setting up the storyline and environment that I wanted to draw. You can find those details on the facing page. Using that established scenario, I then created three illustrations to demonstrate the process for this book.

You will all have different settings for the characters and storylines that you want to draw. Use your own motivation to think about what kind of pictures you want to draw. The things that you want to convey and prioritize are essential parts of forming a composition.

Don't get too hung up on the layered examples portrayed in this book, think about your own composition and how you want to draw it. I hope that by following me through the production process, you can see the methods for how compositions are created and understand the basic principle that "a composition is determined by what you want to draw."

—Rui Tomono

What Does Composition Mean Here?

The conventional concept of composition is thinking of it as "the shape, size and arrangement of people and other elements, and how this relates to directing the viewer's attention as they view an illustration."

However, this is only part of it. The level of detail, lighting and color factor into this as well. Each aspect is important to forming the overall composition—including depth and three-dimensionality (in 3D CGI, this is technically speaking the "Z axis"), context, a sense of presence and atmosphere. In other words, all the elements that are used to construct an illustration, along with all the various contrasts expressed in that image, form the basis of the composition.

I collectively term these factors as "contrasting levels of focus."

How much sense of scale is there, how much sense of depth, and what kind of impression is being created? Contrasting the elements in the illustration and guiding the viewer's gaze means that people will "read" the information you want to convey. Effective composition in an illustration means you are allowing viewers to "see" (understand), rather than just having them "look." Contrasting the levels of focus allows you to convey your intentions to the viewer in a single glance.

It might seem challenging at the outset, but in this book I will explain how to set up a composition in a visual, easy-to-understand way.

I hope this book will help you in your creative work.

Hello, I'm Shikigami, a spirit paired with the protagonist in the drawing on the facing page. My role in this book is to add helpful supplemental information and some comic relief. I'll be seeing you!

I'm Repi, and I'm a spirit paired with the heroine. I'll be appearing with Shikigami to give some easy explanations and chat together.

The Story Featured in This Book

(Pages 25, 65 and 93)

A Magic-Using University Student Becomes Disillusioned with the Big City

▶ **Genre** Modern fantasy
▶ **Setting** Japan, springtime, c. 2040
▶ **World Setting** Magic exists, but is regarded as antiquated. It is used in rural areas by the elderly. In the cities, people do not use magic. A growing number of children and adults are not aware of the existence of magical barriers that ward off monsters.

▶ **Motifs** People in rural areas carry a staff. Affluent tourists are on the lookout for the next photo op.
▶ **Scenario** To continue his education, the protagonist has come to a city where magic is no longer used. He is derided as a hick for carrying a staff, and he has difficulty mastering the use of electronic devices.

During construction of a subway station, an accident disturbs a magical barrier, awakening a huge monster that had been sealed behind it.

The protagonist, who possesses powerful magical abilities, learns how to perform binding magic from an elder and traps the monster.

Character Sketches

The Protagonist

A student at a Tokyo university majoring in Western magic, his family owns a spirit cultivation business (which transforms the life essences of plants into spirits). He enjoys giving cool names to the trivial magic he performs. (For example, a spell that can chill a warm drink—"Eternal Force Blizzard." Note: Can only be used with cola, and lost fizz can't be restored.) He has mastered only the basics of magic, but is assisted by a powerful spirit—Shikigami. He has a family affinity for Western magic, loves outdated battle magic and is well versed in everyday magic.

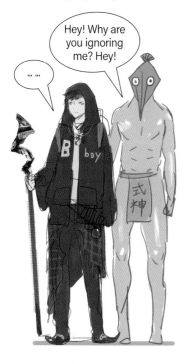

Hey! Why are you ignoring me? Hey!

... ...

Shikigami

A guardian spirit paired to the protagonist at age 13 to invigorate him after a bout of illness. In an effort to produce an unusually strong spirit, a series of prototypes were conjured, combining various attributes. During the process, there was an accident and one of the spirits derived from fermented soybeans mutated, spawning an abnormal species that has a slightly pungent smell. It has rejuvenative power and performs strangely in battle, preferring hand-to-hand combat. It is demure, with a somewhat feminine character. It is also naive, which can be annoying, but it has a penchant for saving money.

The Heroine

Attends the same university as the protagonist. She is majoring in Eastern magic. She comes from a family without a magical tradition. When she was young, she was exposed to a dangerous surge of magic and was saved from the brink of death by magical medicine. Ever since, she has wanted to become a magical healer.

She is a brilliant, mostly self-taught student who apprenticed with the university headmaster. She is embarrassed of her unmagical roots, and has a bit of a mean streak. She acts entitled and can be calculating. She is more knowledgeable than her peers who come from magical lineages. She is skilled in herbology. She stubbornly refuses

to reveal the spirit paired with her and will disavow it if it's discovered. She enjoys collecting knick-knacks. She is interested in the protagonist, who, despite coming from a magical family, treats her fairly even though she's a "regular" person (plus, he has a unique spirit not recorded in any literature).

Repi

The spirit attached to the heroine. It has "old-spirit syndrome," a rare condition usually contracted from its master's corrupted temperament. In the case of the heroine's spirit though, it is a hereditary condition.

When the heroine has done a good deed or is in a good mood, the spirit may temporarily return to its original fluffy, cute state—but only for a moment. It likes to explore narrow spaces.

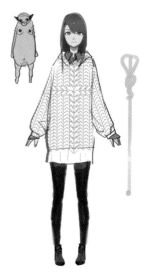

The Cover Illustration

Do you have instances where even though you can draw the characters, they don't look quite right or you feel that something's missing? Perhaps your aim is to draw the environment and characters that you have created to form an illustration that has the impact of a movie poster, similar to the cover of this book.

Perhaps that's even why you picked up this book. I will start by explaining the concept of composition that creates the most attractive characters and environments.

What I Wanted to Convey in This Illustration

A Modern Fantasy Environment and the Protagonist

"The composition is determined by what you want to draw"—I created an environment for this illustration based on this simple principle. That's why it takes on the unique form of an illustration for the cover of a technique book. It wasn't a case of drawing to simply match the style of the publication. In order to draw this cover image, I started by envisioning the stylized surroundings and then made a draft sketch. I then created an illustration based on that. I will explain the process here. The important point for key visuals and cover illustrations is that they should be able to instantly communicate the essential details of the imagined world to the viewers and capture their interest.

The purpose of this illustration is to convey at a single glance that it is a modern fantasy setting. That's why I have included contemporary items (a pedestrian crossing and utility poles) and current fashion. I've also added elements with a strong fantasy vibe such as magic staffs and spell effects in the same image. This was created to convey the basic premise that this is a fantasy story set in a modern society.　　(Commentary: Rui Tomono)

Production Requirements

Specifications

With any type of media, the cover and key visual have design constraints. This could be the title, the tagline or other information contained in a burst. Here, the composition has been based on the assumption that some type of text information will be added as elements. Before starting work, confirm thoroughly with the client about the position of the title, subtitle, etc., and any other specifications. These will affect the placement of elements and would cause a lot of extra work if they needed to be changed later.

Conveying What You Want to Say Attractively and Accurately

The following are the work requirements, based on the specifications. First, it needs to stand out. It must catch the consumer's attention and get them to pick up the product. It therefore has to be attractive. Second, it has to concisely convey the setting and content. It has to satisfy the expectations of the customer who has picked up the product. Which person is the protagonist, what is happening, and what challenges are being revealed? All of this has to be conveyed visually. Composition acts as visual guidance. The composition must communicate a snapshot of the story visually, making this much more than just an attractive image.

(Commentary: Studio Hard Deluxe)

Specifications for This Book's Cover

Title & Subtitle Placement

Publisher's Logo & Authors' Names

• Refer to page 23 for the illustration's world setting and background story.

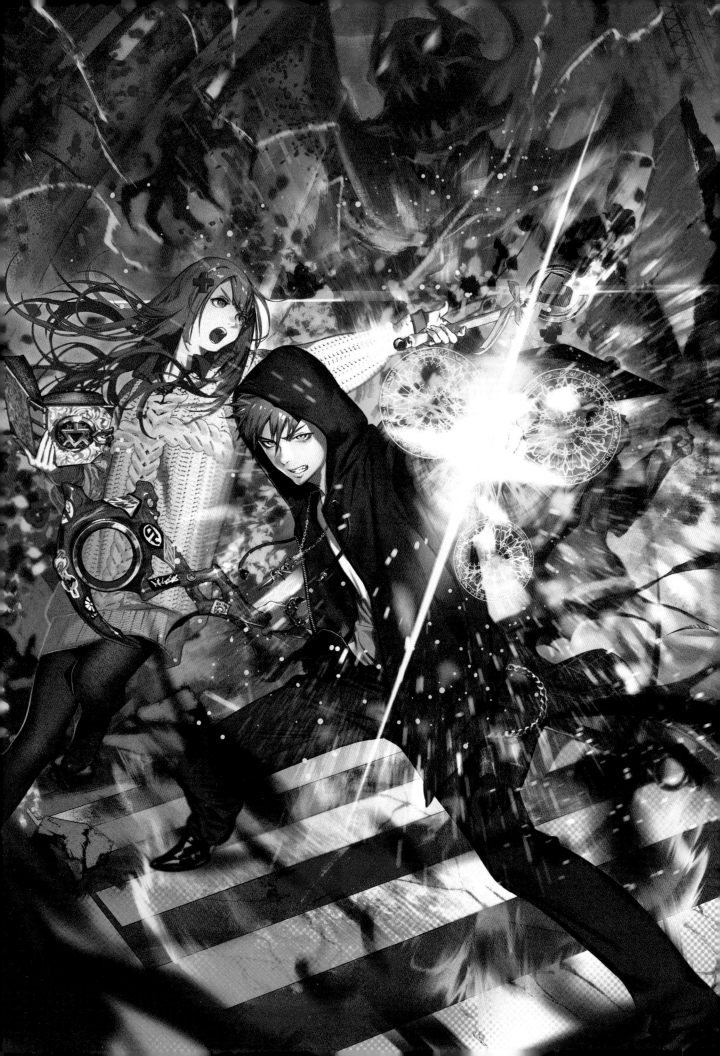

Using Straight Lines to Easily Guide the Eye

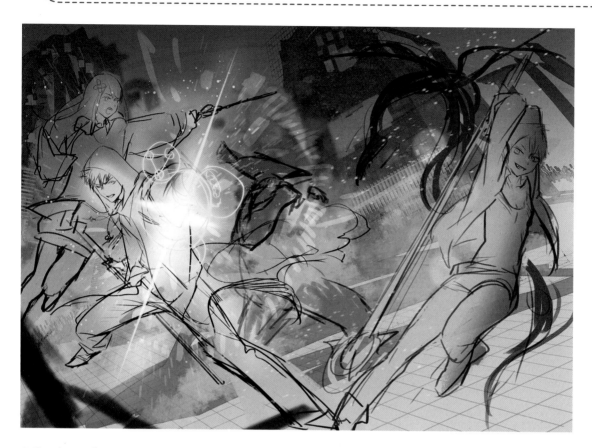

A flow has to be created within the image to guide the eye so that the viewer can gather information from a picture. As I also explain on page 78, lines are capable of directing the focus. Straight lines are particularly powerful and, under the impression that the front and back covers would be a single unbroken image, I envisioned one illustration and created a first rough draft. Whether the viewer was looking at the whole image or only at the half that forms the front cover (in this case, the left half), I needed to think about how the gaze can be guided without hindrance. Since the main element of this picture is a person, I designed it so that person could be seen repeatedly three times.

But the picture above got shelved due to specification changes partway through.

It can't be helped. This work involves a lot of different requirements.

It was lucky this time that the changes weren't made just when the picture was nearly complete. It's best to have proper meetings and discussions for work.

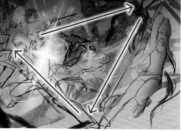

Looked at as a whole, this is a triangular composition (see page 14). I thought to make the surroundings darker and use strong lighting effects for the protagonist so that the eye would be drawn there first. The lighting effect guides the gaze in a rotary fashion that follows the straight lines of the tools held by each of the three figures.

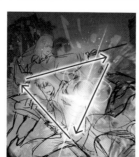

On just the front cover section, a long flare of light is generated through use of the effect, forming a triangle with the protagonist's and the heroine's staffs.

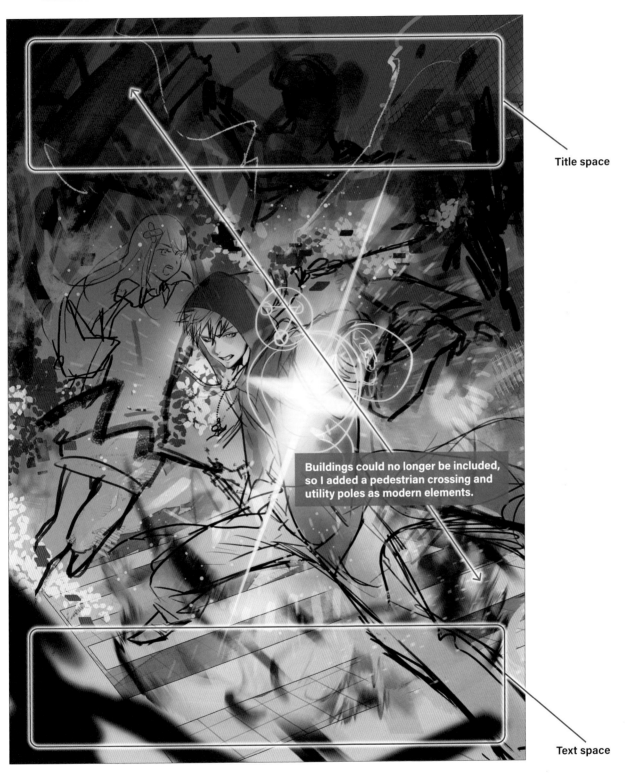

Title space

Buildings could no longer be included, so I added a pedestrian crossing and utility poles as modern elements.

Text space

Maintain Image Density by Positioning Low-Priority Elements in Areas Where Textual Information Will Be Added

The specifications for the work this time meant that the main section of the illustration had to be placed in the available space in the center. That limited the elements for the composition. It was important to create a picture that would be an eye-catching cover illustration within those limitations. After this, I needed to rethink the elements necessary for conveying the setting and how to arrange them within this reduced space.

3 Avoiding Human Anatomy Mistakes

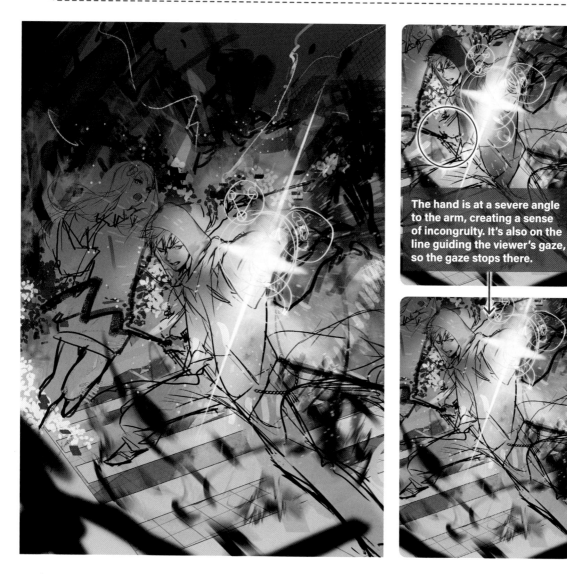

The hand is at a severe angle to the arm, creating a sense of incongruity. It's also on the line guiding the viewer's gaze, so the gaze stops there.

At this stage, we're moving from the rough draft to sketching in and improving drawing consistency, character expressions and poses. If the anatomical structure of the body isn't right, the viewer will sense that something is off and their gaze will stop moving.

People who teach art often say it's better to have as few incongruities in human anatomy as possible. This is because those mistakes create a lot of distraction to those viewing the composition.

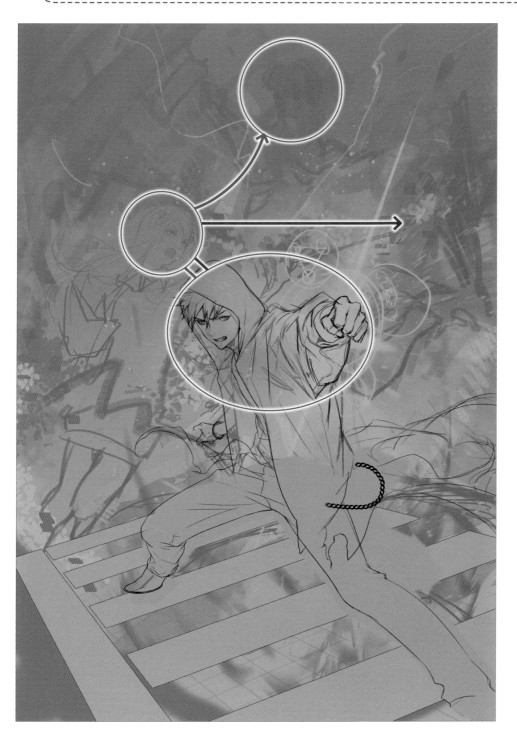

Current ideal
path of gaze

Path of gaze
with title in
place

I've redrawn the character here using clean lines. While creating this clean copy, I checked that there were no inconsistencies in the drawing and that the guidance of the focus of attention was functioning correctly. So this step incorporates cleaning up the lines with checking the composition.

At every stage, keep in mind the composition (guiding the focus of attention, highlighting key elements, creating a sense of depth). This is a key point in creating a picture. The poses of the characters are also determined with the guidance of the viewer's roving gaze in mind. Here, the viewer's gaze is focused on the protagonist visible in the foreground, and then it's drawn to the heroine behind, and finally the creature in the background.

Due to the title being placed in the top section, the creature at the back is no longer visible and the path for directing the viewer's focus has been lost. Nevertheless, I felt that the angled line of the heroine's staff ensured that the eye is still being guided along an effective path.

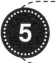

5 Emphasizing the Angled Lines of the Body and Arms to Express Dynamism

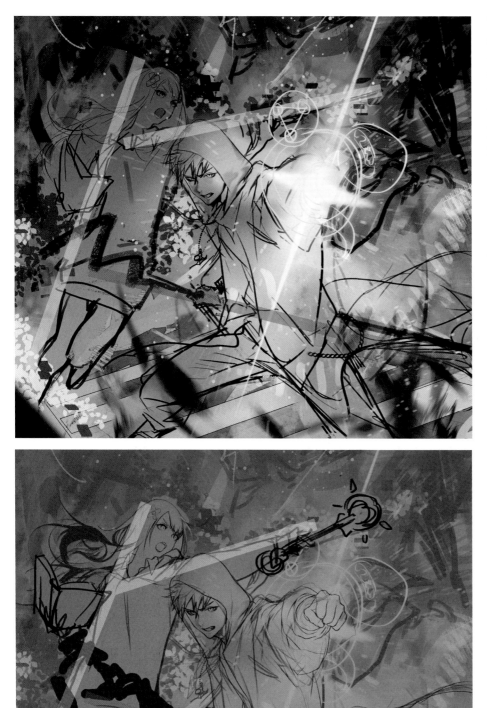

This continues on from step ❹, with me still creating the clean copy and checking the composition. By sharpening the angle of the bodies and arms, it adds a sense of dynamism and movement to the people. I checked to make sure the ideal imaginary line (path guiding the gaze) didn't veer off through over-prioritization of this effect.

A dynamic feeling can be expressed when an angle is viewed as a simple line. This means though that it could also possibly affect the guidance for the viewer's gaze (such as changing the point where the focus leads to or scattering the focus). While adding motion to the characters is important, if the composition, which forms the basis for the whole piece, breaks down, it comes to nothing. When envisioning the details, be sure to pay attention to maintaining the overall composition.

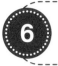

6 Ensuring That the Viewer's Gaze is Guided by Character Lines

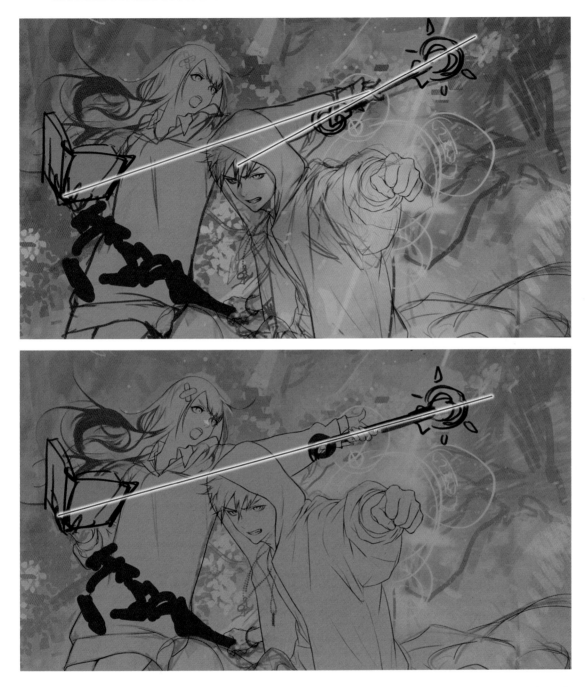

Here, I focused in on only the characters and checked the flow of the drawing and how the viewer's gaze is being guided. As I redrew the characters with just clean lines, they merge with the background details, making it difficult to check them. I worked around this issue by reducing the contrast in the background, so that the character line drawings stand out.

I adjusted the angle of the line that the heroine's staff forms to simplify the lines guiding the gaze created by the staffs held by both the protagonist and heroine.

It's a very slight change in angle. I wonder if you have that amount of subtlety?

What a thing to say!!!

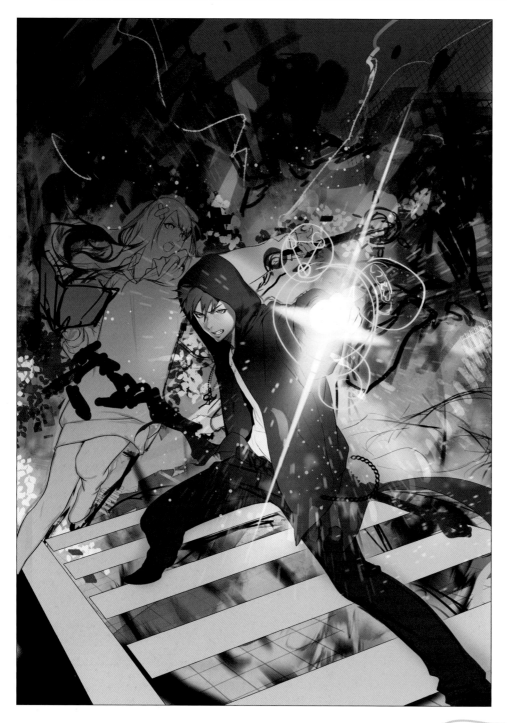

I added a color base to the protagonist to enhance his presence. It is at this point that I restored the background contrast and checked how the viewer's gaze is being guided across the entire image, not just by the character. Emphasizing the presence of the protagonist has made it easier to be aware of the imaginary line that starts at the tip of his left foot, guiding the viewer's gaze deeper into the 3D space depicted in the picture.

The protagonist, who acts as the main element in this image, has to be completed first, as much as possible. That's because he's the reference for the whole image.

That's right. After this, adjustments will be made to the heroine, acting as a supporting element, so that the way she is drawn and her presence don't overpower that of the protagonist.

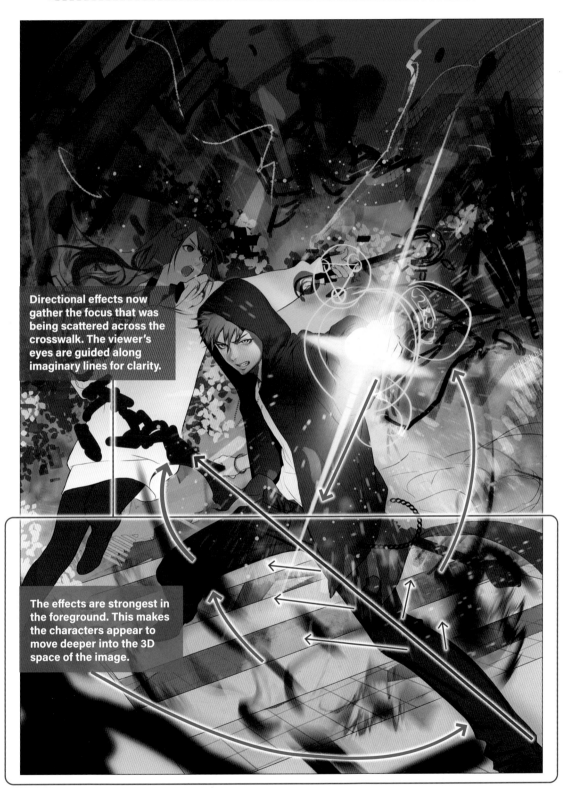

Directional effects now gather the focus that was being scattered across the crosswalk. The viewer's eyes are guided along imaginary lines for clarity.

The effects are strongest in the foreground. This makes the characters appear to move deeper into the 3D space of the image.

The Versatile Magic Effects Are Important— Take Care When Placing Them in the Image

I've repositioned objects, or here, magical effects, that are in the foreground (in this case, around the protagonist's feet) to increase the impression of depth and space. The lines of the crosswalk were mostly uninterrupted white bars, giving them too much emphasis in the image.

This resulted in the viewer's gaze being drawn too easily to focus on the feet. I deemphasized the crosswalk with "magic" effects to weaken that tendency.

Color Design is Another Important Consideration for Composition—It Can Emphasize or Deemphasize Certain Elements on the Screen

Now, we'll think about the composition in terms of contrast and intrinsic colors. Up until this point, the composition has been portrayed through the placement and revision of the silhouettes of the characters. But even if the composition is attractive and well-organized from that silhouette-type perspective, the viewer's gaze can be scattered by striking contrasts and vibrating colors.

At this stage, we'll start making revisions with these factors in mind.

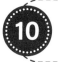

The more detail and the greater number of colors there are, the stronger the presence becomes (see page 107 for reference). When it comes to making the main element stand out in a composition, there are various other ways of doing this besides altering its placement and size within the image. This process can be challenging because the increased amount of detail clutters the image, making things hard to see.

You draw a little and then hesitate because the composition looks like it will fall apart and then you just want to erase it… The balance of density in the whole picture is suddenly out of kilter.

I totally get that… But if you want to get it right, you should draw everything you need all together. Stay the course!

Adjusting Compositional Depth Based on the Distance Between Elements

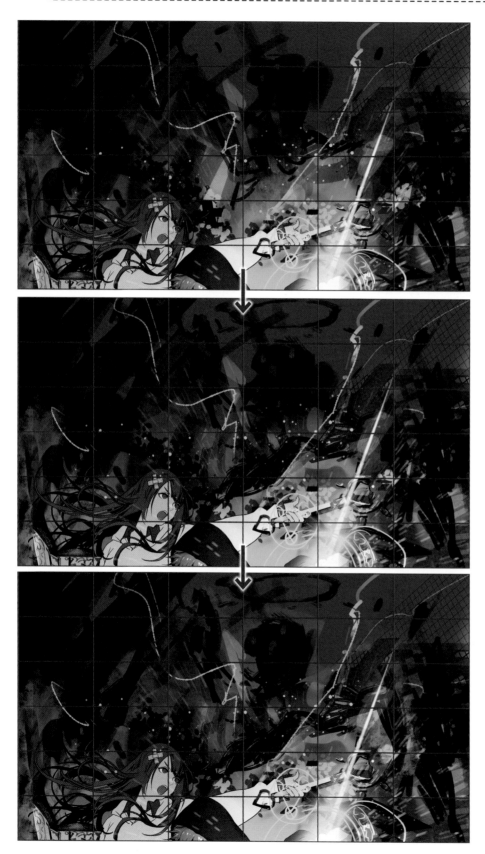

I adjusted the position of the creature to which the back half of the character's angled line is guiding the viewer's gaze. I thought about how much of the protagonist's magic effects should be shown in the image.

Up until this point, the effects of the protagonist's magic have been emphasized, while the presence of the creature positioned in the background of the picture has been subdued.

The creature first needed to be given a concrete shape and brought slightly closer to the main characters.

If I enlarged it more or brought it closer than this, the silhouettes would cause the composition to fall apart.

To emphasize its unusual presence, I made the creature stand out using lighting effects. The sense of distance between it and the main characters has been narrowed considerably. The impression that it's advancing is now present.

 Color Can Also Cause Division in a Picture

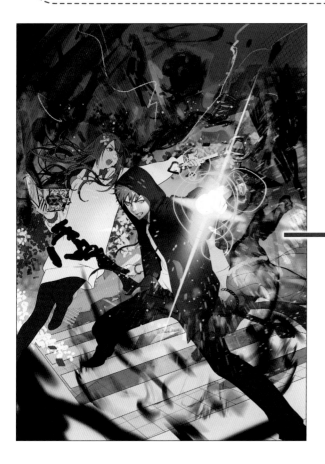

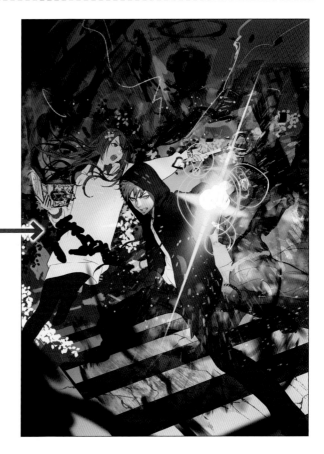

The Balance of Colors in a Picture is an Aspect of Composition, Having the Same Impact as Shapes

The colors in this image felt stark. This was an image with many cool colors, so I added warm colors for the intrinsic color of the ground. But the area where I added those colors neatly fit into the bottom third of the picture. This didn't look right either as it was too regular and too conspicuous. This can be compensated for later by adding effects and detailed objects. So here I prioritized increasing the number of colors and kept going.

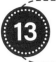
Increasing the Background Detail to Eliminate the Overall Sense of Incongruity

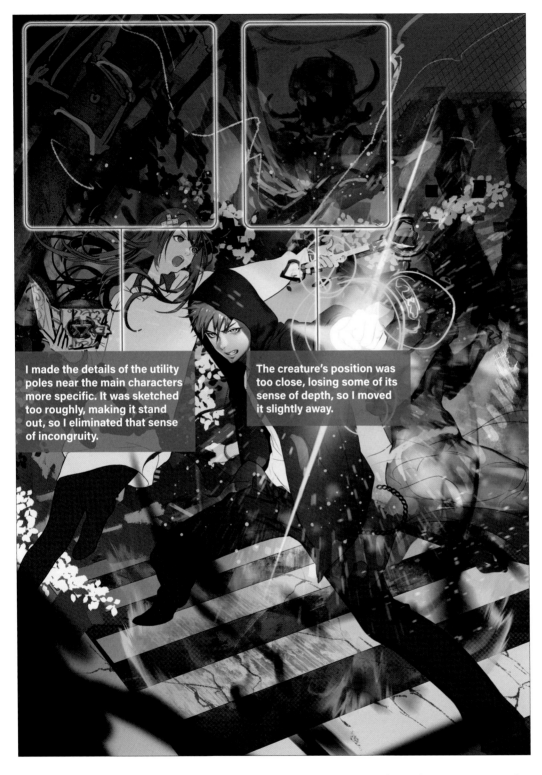

I made the details of the utility poles near the main characters more specific. It was sketched too roughly, making it stand out, so I eliminated that sense of incongruity.

The creature's position was too close, losing some of its sense of depth, so I moved it slightly away.

The area in the foreground is nearing completion. At this point, I neatened up the details of the creature and the utility poles in the background. This also acted as a way to ensure that the viewer's gaze is being guided along the in-tended path without disruption. As explained on page 30, it's best to carry out a check at each stage of the creation process to make sure there is no incongruity in the depiction of detailed elements or the composition as a whole.

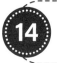

Making the Subdued Background and Surroundings More Vivid When Viewed in Their Entirety

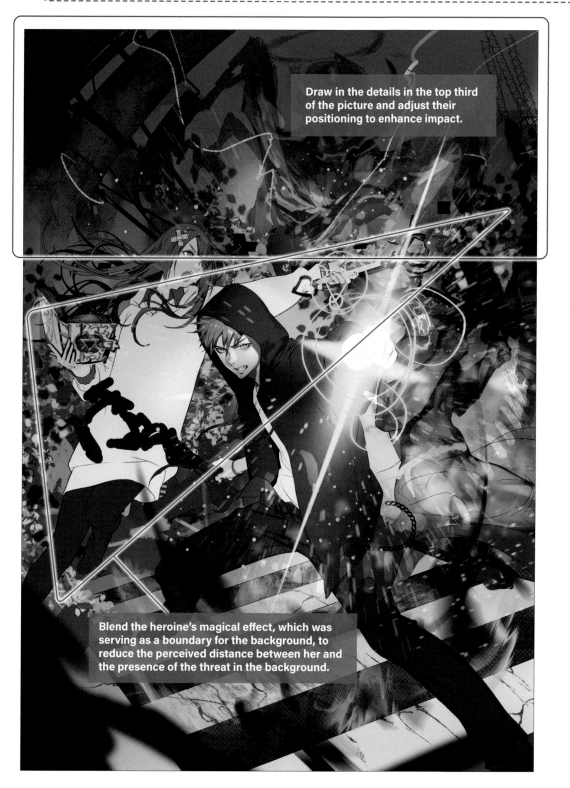

Draw in the details in the top third of the picture and adjust their positioning to enhance impact.

Blend the heroine's magical effect, which was serving as a boundary for the background, to reduce the perceived distance between her and the presence of the threat in the background.

Up to this point, I've made adjustments that emphasize guiding the viewer's gaze, but now we want to balance the impact created when the picture is viewed as a whole. Here, I've set aside the silhouette-style composition and depicted the creature's subtle movements and other aspects. Of course, after adding these details,

I need to check again to make sure there has been no shift away from the basic intentions of the piece.

Rather than working on each detail in a picture until it is completed, gradually work on all the elements, comparing them to ensure that the work nears completion as a whole.

 ## 15 Adjusting the Lighting and Details

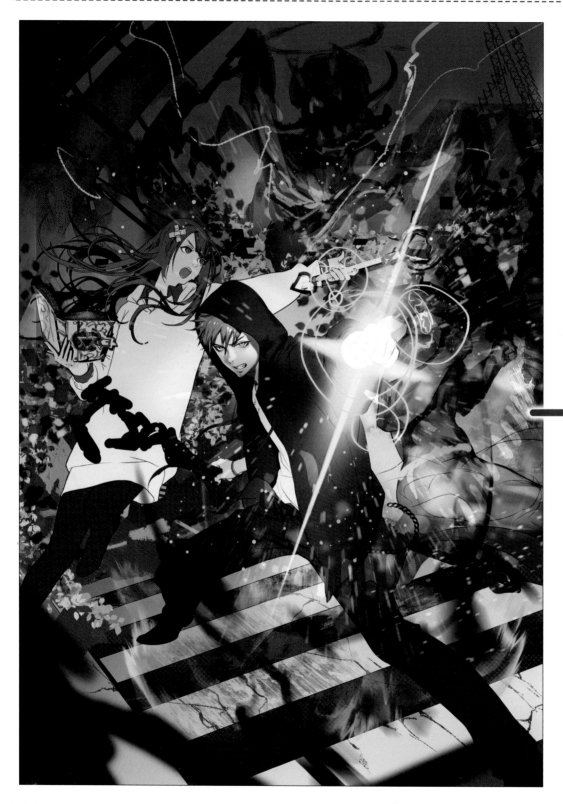

Simply deleting or increasing the number of objects is not the only way to create an easily comprehensible picture or composition. As mentioned before, the viewer's gaze can also be guided through manipulating the placement and intensity of contrast, and by the intensity of light striking an object.

This is what I aimed to demonstrate here.

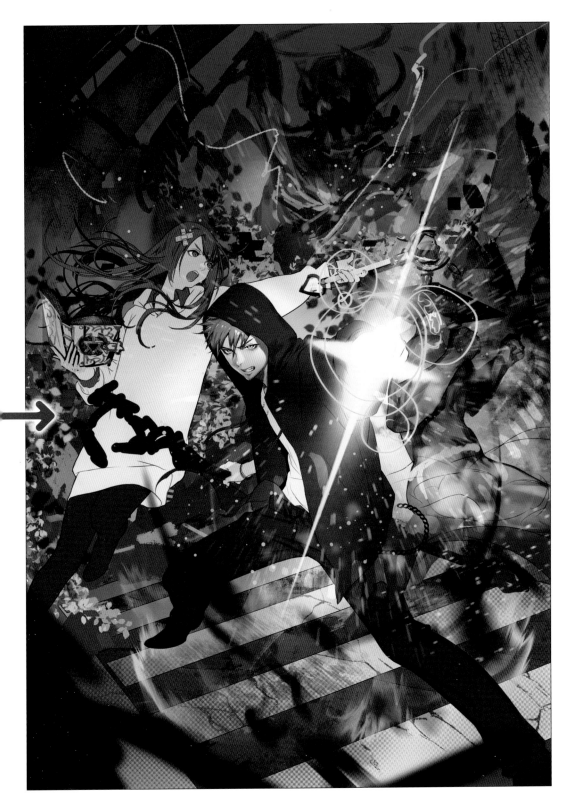

Using Differences in Color Intensity to Alter the Impression and Guide the Viewer's Gaze in the Intended Direction

The image is dominated by cool colors, so I changed the light effect coming from the protagonist to a warm color.

This draws even more focus onto the protagonist in this picture. I softened the overly busy details on the crosswalk by dimming the lighting there, so now the focus in the composition falls on the protagonist in a more straightforward way.

Optimizing Presence, Depth, Distance and Details

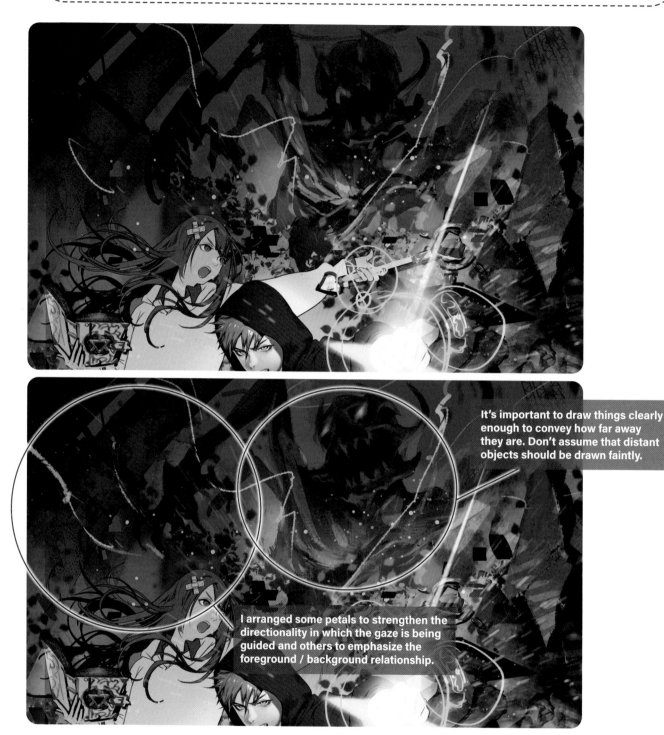

It's important to draw things clearly enough to convey how far away they are. Don't assume that distant objects should be drawn faintly.

I arranged some petals to strengthen the directionality in which the gaze is being guided and others to emphasize the foreground / background relationship.

The amount of focus I gave the protagonist in step ⑮ meant that once again the creature's presence became weaker. In terms of being in the background, sometimes the presence can be conveyed even if it is faint. But, as explained at the beginning, the main requirement of this piece is to portray the setting. Here, I envisioned the imaginary line guiding the viewer's gaze to encounter the protagonist, heroine and creature. Following that path of focus means the viewer has to understand the depth of the picture and sense of distance between the main characters and the creature. In this case, rather than conveying depth by creating atmosphere, it was better to draw several subjects and express space through a comparison of how they are depicted. This means that even though the creature in the background is positioned right at the back, it is as important as the very forefront of the picture. If the foremost or hindmost sections were lacking, it would weaken the significance of their presence in the image.

17 Enhancing Focus on the Primary Elements in a Balanced Way

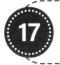

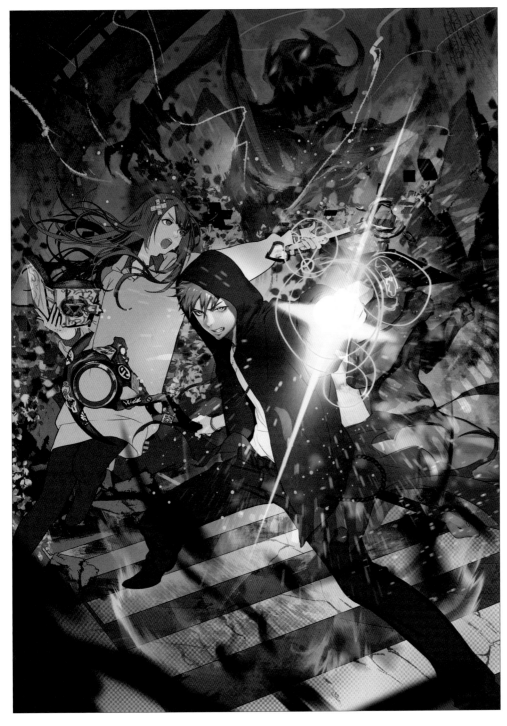

I arranged how each object (including characters) should look while keeping in mind the whole picture. As I've been explaining, increasing the focus on any one element will relatively weaken the impression of the other elements. Here, I enhanced the details of the protagonist and the creature simultaneously to keep them in balance.

Drawing in details is annoying, isn't it? Up to now, this would mean simply improving the picture, but that's not the case when it comes to composition.

As I mentioned before, composition is ultimately contrasting levels of focus. This book posits that the more detail you add, the greater the focus.

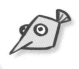

Recap—The Process So Far

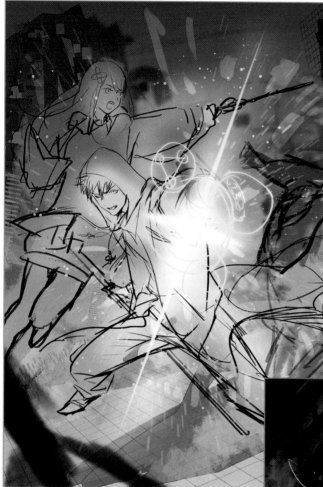

First Rough Draft

We started with a first rough draft that focuses on how the viewer's gaze will be guided. Regarding the angle of the ground, as long as it can be seen to be sloping, that is fine.

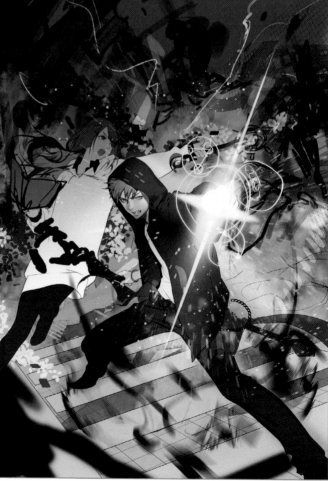

Line Art and Main Colors

At the line art stage, we eliminated incongruities within the whole picture and decided the position of the elements along with the main colors to be used.

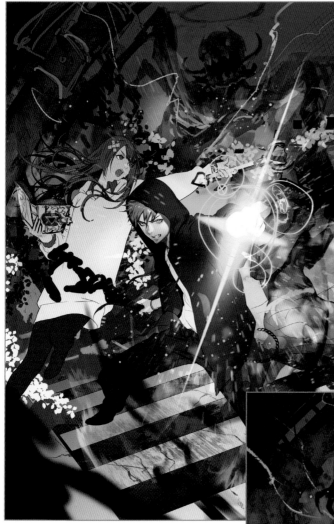

Coloring and Adding Background Details

From the line art and color stage onward, we made adjustments to the colors and to the assumed points of focus, bringing them as close to completion as possible. At this stage, remember to pay close attention to the depth of the picture.

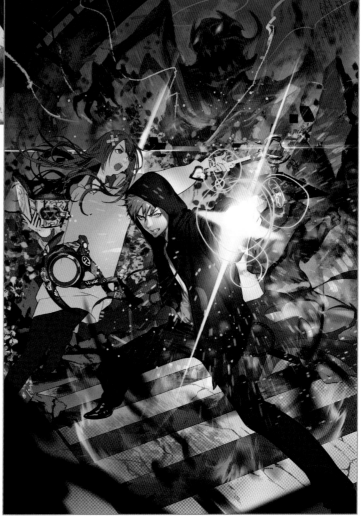

Adding Fine Details and Resizing Elements

This is our current stage. Almost all the rough sketching has been replaced. Remember to frequently check the points of focus when the picture is viewed as a whole. If needed, add effects or adjust the colors.

(Commentary: Studio Hard Deluxe)

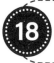

Emphasizing the Protagonist to Accentuate Their Leading Role in the Illustration

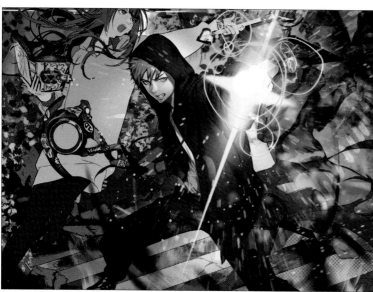

Having drawn in the details of the surroundings up to this point, it's appropriate to now add more detail to the protagonist (but it's best not to change the style). Here, I systematically improved ambiguous areas, such as the edges of the clothes, accessories and circular magical sigils that were still vague in appearance. Doing this makes it possible to increase the strength of the protagonist's appearance, in addition to the whole picture.

The picture is getting closer to completion, isn't it? When will my main character (the heroine) start having details added?

On the facing page, we'll be fine-tuning the protagonist's details. That will make his presence really stand out. Work on the heroine is going to have to wait just a little bit longer.

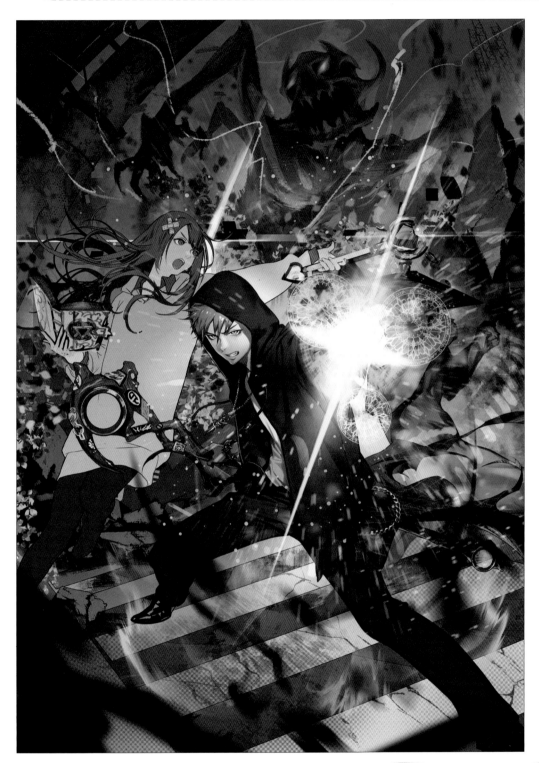

Drawing in the magical effects has strengthened the impression that this is a story about modern magic. To be honest, I was worried up to this point about the difficulty of communicating to the viewer that this is a modern fantasy. But now this sense of fantasy has increased. It seems to meet the requirements for the setting I was envisioning for the cover illustration.

If the circular magical sigils were drawn at the start, that would have been enough to make viewers understand that this is a fantasy. Except for the main character, it's a good idea to leave drawings of potent elements that convey the story until now.

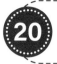

20 Check Again Every Time the Level of Focus on an Element Changes

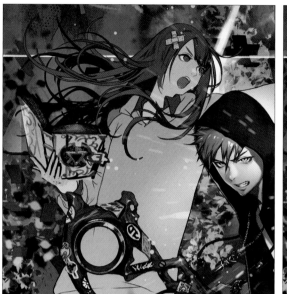 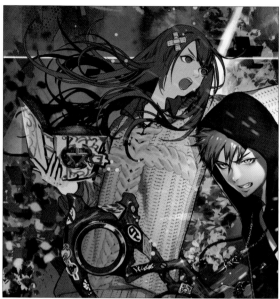

Now that the protagonist in the foreground is pretty much fixed, I will start depicting the heroine, who is positioned at a nexus of the "paths of focus."

At this stage, I won't mindlessly begin the work of drawing clothes or applying lighting effects. I want to depict the heroine centrally positioned in space between the 3 elements (protagonist, heroine, creature).

As mentioned before, I do this to portray space through comparison. I have given the heroine less contrast than the protagonist, but more than that of the creature.

This increased focus on the heroine made me think about the position of the flare around the protagonist's magic sigils. So I adjusted that. It's in this way that you become aware of incongruities as the level of focus changes.

Once you have completed the detailed drawing of the protagonist, you will tend to feel a level of satisfaction and be tempted not to pay as much attention to other details. So even though the drawing is mostly finished—and I keep saying this—you need to constantly check to ensure that there are no incongruities in the picture.

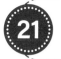

21 Complete the Supporting Element with Slightly Less Prioritization than for the Main Element

Here, I filled in the details of the props that are associated with the heroine—the spellbook, wand and clothes. As can be seen through comparing her to the protagonist, I've kept the amount of fine detail, the contrast of the shadows and the strength of the lighting one step below that of the protagonist. If I were to add more details, it would diminish the protagonist's presence as the main element.

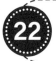
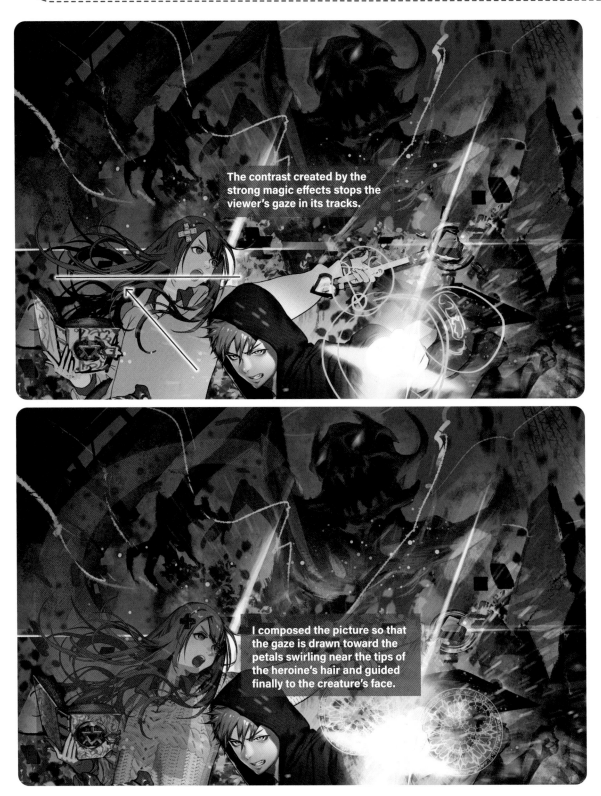

The contrast created by the strong magic effects stops the viewer's gaze in its tracks.

I composed the picture so that the gaze is drawn toward the petals swirling near the tips of the heroine's hair and guided finally to the creature's face.

I adjusted the heroine to be a connecting link in the path of focus from the protagonist. If the contrast is too strong, it will be like the viewer's gaze has hit a wall. This would constitute a failure to achieve the intention at the outset of the envisioned composition.

The heroine is positioned close to where the path of focus angles over to the right. Even though she is a single element, she needs to create a pathway through which the viewer's gaze can flow to connect with the creature in the background.

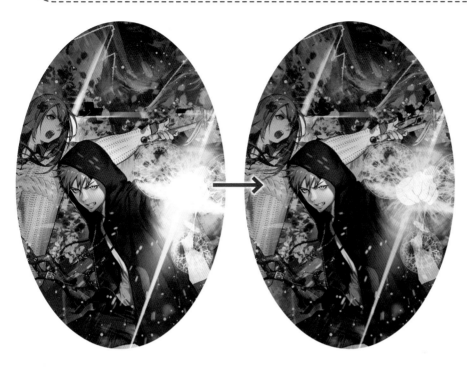

Softening Elements that are Too Distinctive and Ensuring the Information Can Be Read Clearly When Viewing the Whole Picture

Here, we look at the entire picture. I felt the effect emitting from the protagonist's hand was too strong, so I softened it. I specifically reduced the amount of light and changed the hue of the top and bottom sections to neutral colors, so that the colors used blended into the picture.

If the contrast is too strong, it can draw the gaze too forcefully as well. This is a serious drawback, making it difficult to see the objects in the surrounding area, even though the gaze is being drawn there. It of course also interferes with guiding the path of focus.

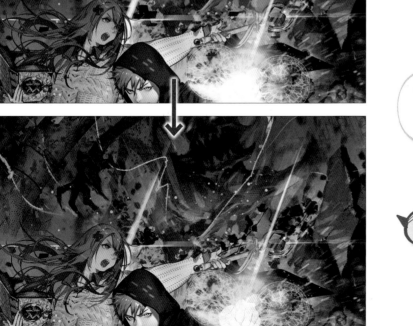

I drew in the effects around the heroine with the same intensity as I used for the character to make it clear that these petals are associated with her flower magic. I adjusted the coloring to make a darker contrast, just enough to guide the eye.

That's strange. My presence is completely hidden behind the magic effect.

I don't see anything wrong. The intention is to hide you.

24 Contrast Distracts the Gaze

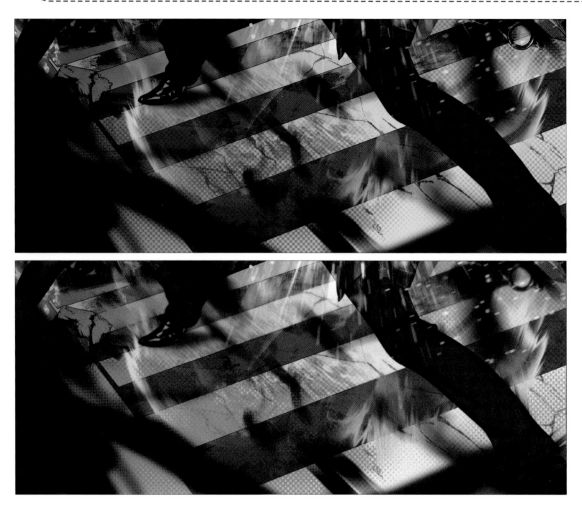

The borderlines of the warm-colored ground that I was concerned about on page 37 have been subdued with the addition of the protagonist's magical effects. Moreover, I have dispersed the intensity of the red by using an effect that radiates out from the feet.

When the picture is viewed as a whole, this effect adds brightness to the entire area. I've also adjusted the balance to make the surroundings easier to see.

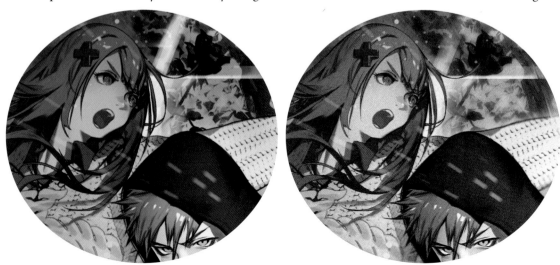

This is an effect to enhance the contrast of the heroine. I followed up by softening part of this so that the path of the viewer's gaze didn't change.

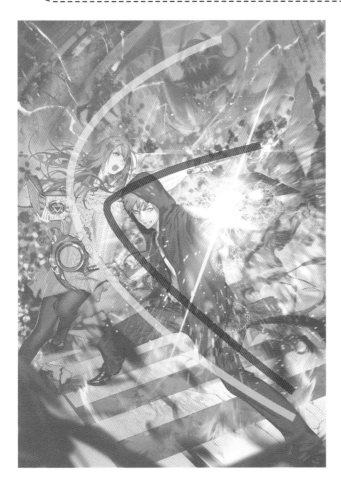

To complete the picture, I adjusted the color tone and effects so that the protagonist's face stood out more. The pink line to the left indicates the adjusted path that the viewer's gaze follows, created once the book's title was set to appear at the top, while the yellow line shows the ideal imaginary line. If you look first at the protagonist and see him as a whole, you can understand how the line of focus gradually moves from the feet up toward the top section of the picture.

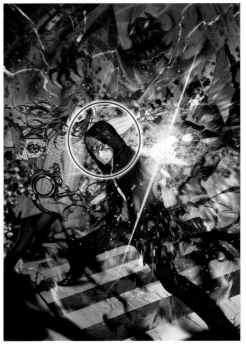

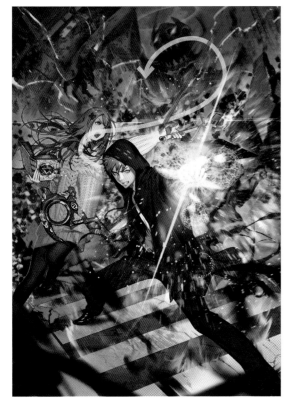

The effects added to the top section of the picture all radiate out from the main characters. Doing this directs the gaze that was guided to the creature back onto the main characters. There is an explanation of this on page 109 too. The viewer, by observing the protagonist, heroine, and creature repeatedly in this way, will be able to comprehend the information being conveyed in the picture.

It's made clear right to the very end how important it is to guide the viewer's gaze when creating a composition. Even those lightning-style lines have the same effect of guiding the gaze.

Professional illustrators make every step count. That said, if you work through the process step by step, it's all just meticulous work. People who draw effectively ask themselves, "Which elements should I focus on to influence the impression of the picture?" If you keep this in mind, your pictures will improve significantly.

Explaining the Basics

Vertical or Horizontal? This is a Basic Question to Consider Before Drawing!

You're ready to draw and you launch the paint program—the first thing you need to do is set the canvas size. Sheets of paper are usually longer either vertically or horizontally, but why?

1-1 What Is a "Canvas?"

A "canvas" is essentially the field of vision from the point of the observing person (reader or viewer). Or if you think of a photograph, it is the aspect ratio of the shot. In painting, the word "canvas" has long been used, as the painting surface is actual canvas. So why do you think it has short and long sides? The reason is connected to the viewer's field of vision.

Field of Vision

Two eyes achieve a range of approx. 200°

The figure shows the field of vision to the left and right when looking straight ahead. Each eye can view up to around 90° to 100° toward the ear and 60° across the nose.

Together, the left and right eyes can cover a range of approximately 180° to 200°. The eyes are aligned side-by-side horizontally so structurally it is possible to observe a wide area.

Approx. 130°

In contrast, this figure shows the vertical range that fits within the field of vision when looking straight ahead. An upper range of 60° and a lower range of 70° can be viewed at one time. As the eyes aren't aligned vertically, the total vertical range is only approximately 130°. This means that a person's field of vision is structured so it is wider to the left and right and comparatively narrower top and bottom.

Landscape or Portrait?

Landscape (Wide)
Now that we understand that a person's field of vision is horizontal, let's get back to talking about pictures. If a picture is in landscape format, it is the same as the field of vision. In short, it reflects a natural structure. The viewer's gaze also moves more easily in a horizontal direction, giving the impression of width.

Portrait (Narrow)
So what about the portrait format? There is certainly the impression of narrowness. At the same time, a sense of height is also created. It is natural of course that the impression conveyed by these long and short sides also affects the picture that has been drawn.
If you have already decided the kind of picture you want to draw, you probably won't need to think about whether it should be horizontal or vertical.

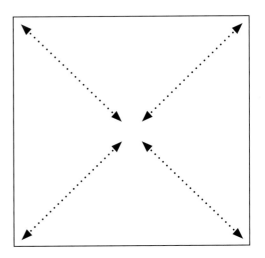

I get it. That's why so many landscapes are horizontal, while portraits and works that depict buildings are vertical.

The human field of vision is surprisingly narrow, isn't it? Their eyes face straight forward, so I guess it's only natural. In my case, I can see around 250° from left to right.

Square
What about a square format where the four sides are the same? This is actually a very exacting format and isn't recommended unless you have a specific intention for its use. What makes it so inflexible is the way it makes the gaze move uniformly. It's not that it is good or bad, it's an issue of suitability. A square is excellent in terms of design, so if that is your purpose, you may want to think about using this format.

Don't Trust the Golden Ratio! Go for the Silver Ratio!

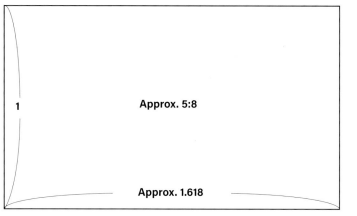

Approx. 5:8

1

Approx. 1.618

Golden Ratio

Leaving aside landscapes and portraits, I'd like to talk about the ratio of the long and short sides. Have you heard of the golden ratio? If you are part of the world of photography or design, you will have come across it at least once, often referred to as "the most appealing proportion." The great thinkers of ancient Greece were said to have discovered it, and Leonardo da Vinci also arrived at those numbers independently. However, there is no scientific way to determine whether these are "the most appealing" or not. When a survey was taken on which ratio for rectangles the general public preferred—the golden ratio or the silver ratio—the data showed more often than not it was the silver ratio that respondents preferred.

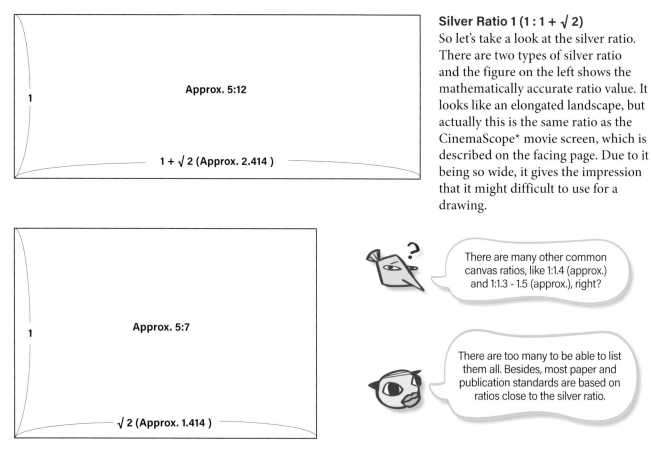

Approx. 5:12

1

1 + √ 2 (Approx. 2.414)

Silver Ratio 1 (1 : 1 + √ 2)

So let's take a look at the silver ratio. There are two types of silver ratio and the figure on the left shows the mathematically accurate ratio value. It looks like an elongated landscape, but actually this is the same ratio as the CinemaScope* movie screen, which is described on the facing page. Due to it being so wide, it gives the impression that it might difficult to use for a drawing.

There are many other common canvas ratios, like 1:1.4 (approx.) and 1:1.3 - 1.5 (approx.), right?

There are too many to be able to list them all. Besides, most paper and publication standards are based on ratios close to the silver ratio.

Approx. 5:7

1

√ 2 (Approx. 1.414)

Silver Ratio 2 (Yamato-hi ratio; 1 : √ 2)

This is the ratio that results when a square is deducted from the width of the mathematically accurate silver ratio described above. Japanese historical architecture fits this ratio, which is why it is also called the Yamato-hi ratio or the Japanese ratio. A-size and B-size notebooks almost always use this standard. A person's field of vision is 180° to 200° left to right and 130° top to bottom, making the ratio approximately 1.384 to 1.538. The silver ratio (approx. 1.414) falls within this range.

*CinemaScope—A trademark of Twentieth Century Fox Film Corporation.

Why is the 16:9 Ratio Often Used?

16:9

The most common aspect ratio for television screens and computer screens (as of 2017) is 16:9. You have probably seen the phrase "Full HD" at one point. This refers to a resolution of 1920 x 1080 pixels*. Those numbers are a multiple of 16:9. Here, I'll explain why the use of these figures is so widespread.

The Cinema World's First Aspect Ratio—4:3

This ratio was decided by William Kennedy Dickson, who made the world's first motion picture. It is not known why he chose this ratio. Nonetheless, it was later adopted for CRT televisions and, together with movies, became common across the globe.

CinemaScope—12:5

Once again, it was the movie industry that decided to go wide. The industry had lost customers through the widespread introduction of televisions, so it came up with the idea to create wide screens that would draw them back to theaters. Following that, movies using various ratios appeared, but the size eventually standardized was 1:2.35, roughly 12:5.

Where, then, did 16:9 originate? Kerns H. Powers proposed this ratio in the late 1980s when a new standard was being developed for television screens. It could fit 4:3, the most common screen size of the previous generation, and roughly 12:5, the current widely accepted movie screen size, in almost the same amount of area.

Now, except for movies, all video productions are made using this ratio. Everyone is familiar with it, so if you use this ratio when drawing, you can draw a picture that gives the appearance of a video image without creating any sense of incongruity.

Eventually even the silver ratio lost its relevancy. But, I've got a better idea now about which ratio to choose. If you're going to be printing on paper, match the ratio to that. If you're going to look at it on a video screen, make it 16:9.

If you're thinking about printing on paper, why not crop it to 16:9, so it can be published online too? Make sure it's a composition that looks good even after you've cropped it.

Clever thinking!

*Pixel—The smallest possible display unit that is used to fill a digital screen.

1-2 Placement of the Elements

Now that we understand what a canvas is, let's move on to deciding the actual content (compositional elements). Of course, the desire to draw a picture is based on wanting to draw a certain character or setting, so I think most people will have already decided the content.

Steps for Composing the Picture

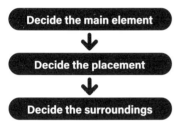

The steps are generally along the lines of those shown to the left. A picture needs a main element.

The main element is what is highlighted, so if this becomes disrupted, you can't draw the picture you want. It's fine to have more than one main element. When creating the rough sketch, decide on the order of priorities. For example, No. 1 is to sketch the brightest area and No. 2 is to sketch a slightly darker area, etc.

Where should it be placed in the picture? This depends on the balance of the surrounding elements. If you're not used to doing this, it will be almost impossible to make an immediate decision. Even professionals have to fine-tune the balance of the placement. If you can get to a point where you can quickly determine that "this placement seems good," that is proof your eye has become trained.

What you place in the surroundings depends on your setting. Give your imagination free rein. In this situation, what kind of civilization exists, what is happening, what season is it and what time of day? What are the characters holding, what are they doing and what are they looking at? Just brainstorm for ideas and then visualize them in your mind's eye. It will lead to creating a great picture!

Pursuing the Picture You Want to Draw

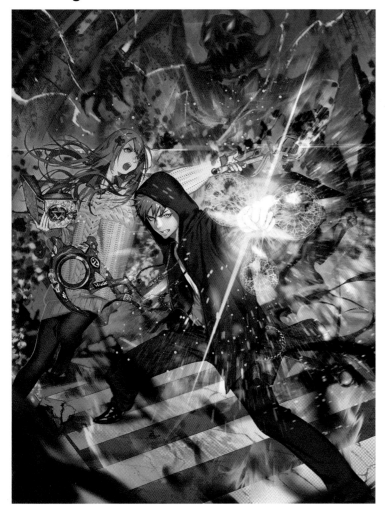

Key Visuals* and Character Illustrations

Spatial consistency isn't so crucial in these illustrations. What is key for these illustrations is that the viewer can see at a glance what is happening and who's doing what.

There are of course some illustrations that have very accurate spatial consistency. In those cases, the "atmosphere" has being given top priority. The main purpose of this type of illustration is to showcase the characters and setting in an enticing manner.

So, it's important to place the characters prominently—at the center of the picture or placed close to the camera (viewer).

Adjustments to the brightness and contrast of the surroundings and the placement of surrounding elements are often made based on the characters.

*A representative image used on websites or other media. Also referred to as a main visual.

Scene Shots and Concept Art

If you think of a movie, the key visual and character illustrations are the ones used on posters. On the other hand, artwork like the drawing shown to the left looks like a scene captured straight out of a movie.

It's important to adjust the characters and the surroundings as a whole in order to make what you want to show stand out the most. The space is connected and the placement of the surrounding elements is mostly consistent, but you can fudge things a little to make the illustration look better. Illustrations are not photographs or documentary footage.

Being able to make things up (shift away from realism) is one of the biggest advantage of drawing.

What Is a Good Basis for the Placement of Elements?

Bisection / Central

Golden Ratio

Rule of Thirds

Central Circle (Hinomaru)

Once you have decided what illustration you want to draw, it's time to consider what basis you will use to place the elements. I've shown some examples above. Each line in the frame acts as a reference point. Ideally, you shouldn't divide the composition first. It's better to place the elements and then match them to one of the compositions. The reason being if you rely too much on a composition's reference lines, it will be challenging to deviate or be flexible with your design.

The reference lines of the composition really are just a reference. If you adhere to them too much, the picture tends to become monotonous. So try to arrange the elements in a way that makes you feel like they are "just right," and if you feel the picture is close to the reference lines of a certain composition type, adjust the elements to align with that. Explanations for the characteristics of each composition can be found on page 4 onward.

So it's actually not a very good idea to set out to draw according to a fixed composition type, right?

But if you're just starting out, you want to follow a reference, don't you?

If you think a picture is good, overlay it with matching composition lines to understand its structure.

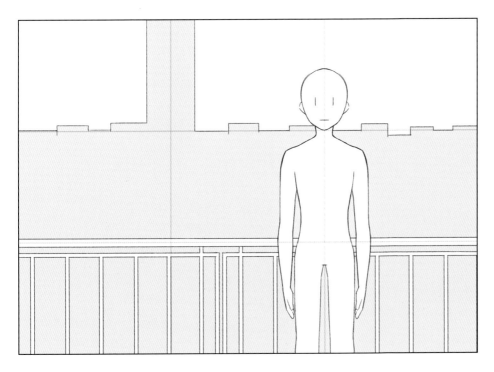

When the Dividing Lines are Used as a Reference

The concept of this is to have the dividing line placed at the center or on the border of a motif. The positions of the standing person and the tallest building are in the center of the vertical rule-of-thirds lines. Meanwhile, the railing of the fence and the skyline both align with the horizontal rule-of-thirds lines. The balance can be improved even more by placing the elements not just on the base line, but where they intersect horizontally and vertically (the points of intersection—"power points").

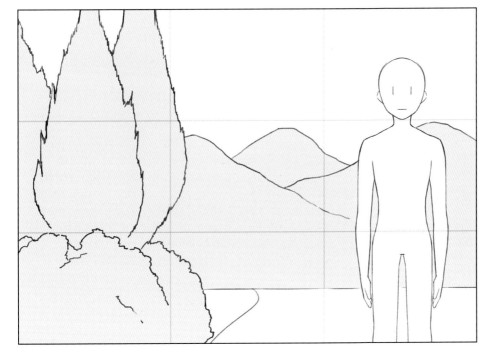

When the Dividing Frames are Used as a Reference

Here, the concept is to place elements within the frames created by the reference lines. The character can be seen fitting within the farthest vertical column on the right. The bushes are roughly the size of the smallest frame created by the left vertical line and the bottom horizontal line. The mountains in the background also fit within the four bottom right frames.

Create Your Own Specification Sheets

When you try to draw something that is in your head, you might find for some reason you can't seem to draw it well. Or maybe you want to place something, but you can't decide what to place where.

When you are wavering like this, it could be that you have too much information in your head and you're not able to organize it. Start with organizing the elements of the picture by writing them down. Then, choose the information you need from there.

Imagined-World Checklist	
Genre	
Local Setting	
Timeframe	
Climate	
World Setting	
Issues	
Main Characters	
Motifs	
Scenario	

Personal Illustration Specification Sheet	
Type of Picture I Want to Draw	
Main Element	
Atmosphere	
Scene	
Time	
Purpose of Main Element	
Size	
Print Resolution	

Compositions Focusing on the World Setting

Not everyone wants to draw illustrations that just focus on characters, right? We usually also want to create magnificent fantasy worlds and beautiful settings, within which our characters come alive.

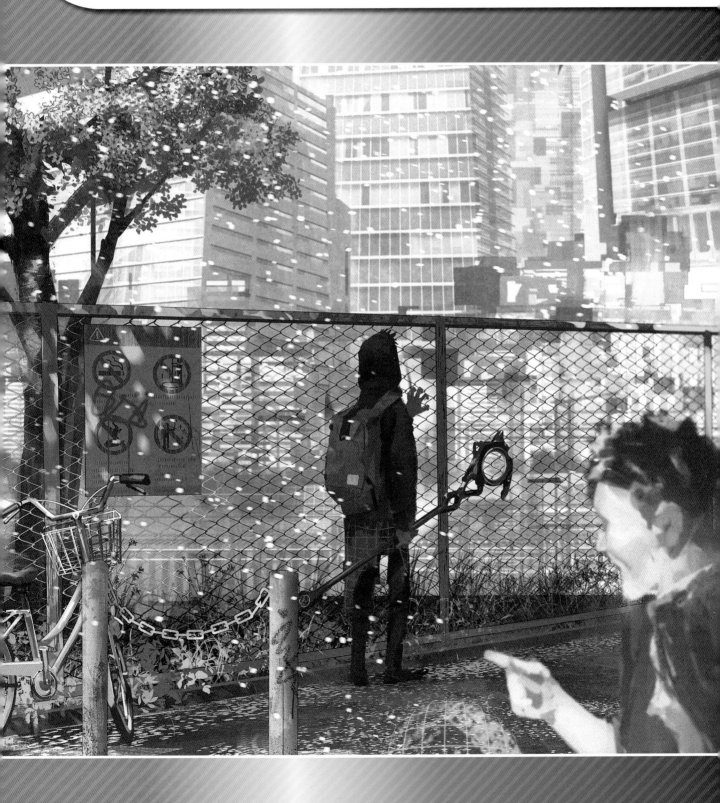

A Core Key Visual That Conveys the World Setting

Title: Cross

You want to delve deeper into the inner lives of the characters. And if possible, to express the world setting at the same time... In this type of situation, consider a composition that focuses on problems or conflicts.

The key point is to choose appropriate elements that can clearly express the timeline of the story and the background of the character you want to draw.

What I Want to Convey in This Picture

1. A More Detailed World Setting

In this illustration, my aim is to create an atmospheric feeling of the world where the protagonist and others live. The cover illustration in the previous chapter conveyed that the genre is modern fantasy. This genre (in other words, the category for the type of world) doesn't give a sense of the setting, such as the region and climate, and we can't know things like how far civilization has developed. In this chapter's artwork, I'd like to draw a more detailed view of the world. So, I've created this picture, envisioning the start of the story.

2. Symbolizing the Protagonist's Concerns

The setting is the near future. Magic has been overshadowed by modern technology. The protagonist has just moved to Tokyo and is experiencing setbacks in the city in regard to magic. Is he going to spend the next few years of university life denying his identity? I want to express his internal struggles in just one image. That's what I had in mind when I created this work.

(Commentary: Rui Tomono)

Production Requirements

Image Board for Key Visuals

As with the example "Unite" in the next chapter (starting on page 92), this has been created with the intention of being like a poster or concept art. However, unlike the cover illustration that is a key visual focusing on the characters, I envisioned this as a core key visual that can be used to explain the world setting in more depth. On the other hand, the content and world setting of the work needs to be conveyed concisely, just like the cover illustration. How cool a character is only really stands out when they are rooted in some kind of complexity. That's what needs to be conveyed here in this picture. My intention is to print this large, so I created it based on A3 specifications.

Refer to page 23 for the picture's world setting and background story.

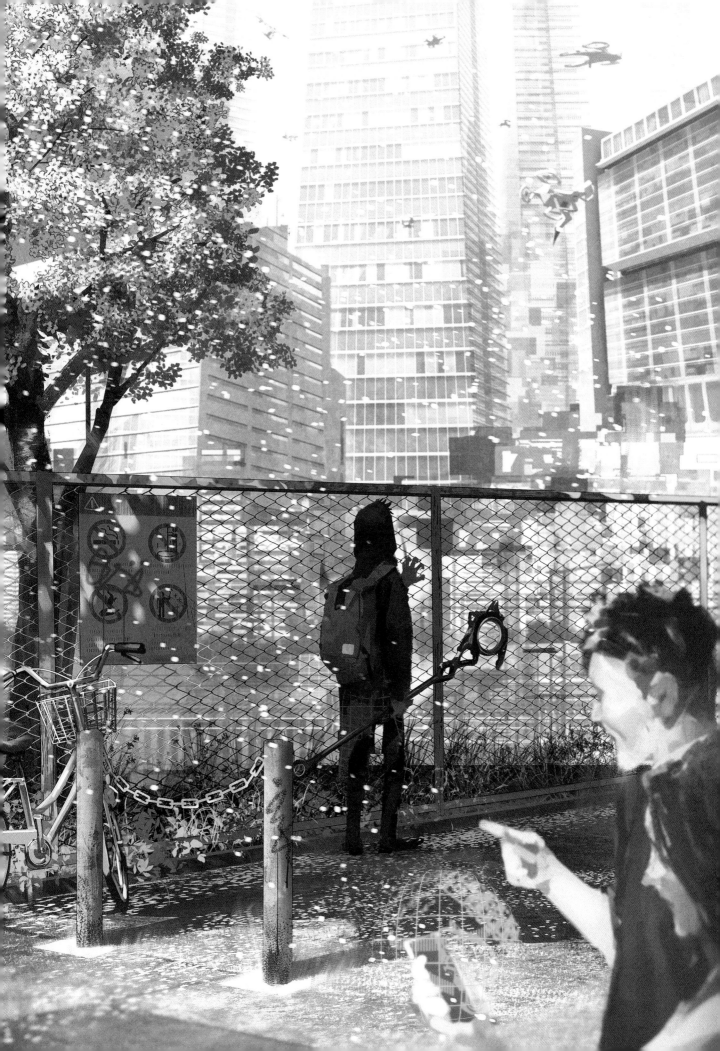

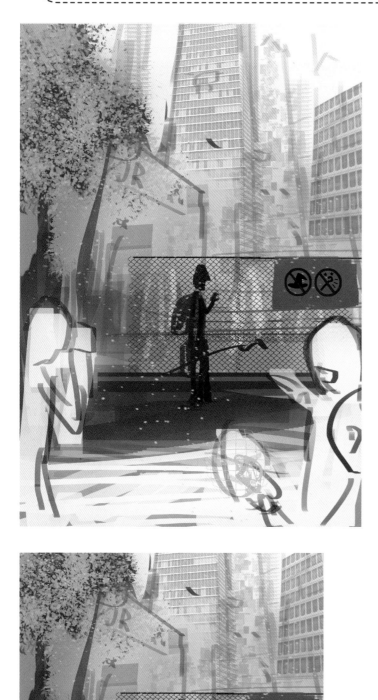

Using the concept as a basis, I started by drawing all the elements I definitely wanted to include in this first stage.

I wanted to give first priority to expressing the interaction between the protagonist and the city, which is the setting for this story. So I thought about a composition in which the imaginary lines would cross over each other. I also used "Cross" as the title of this picture to reflect the meaning of crossing paths with others and the shape of a cross. To express the cross, I created a vertical line along the protagonist and a skyscraper, representing the dream city, and I made a horizontal line by adding a fence that acts as an obstacle to reaching that dream.

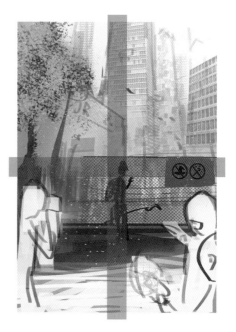

Selecting Compositional Elements

I placed cherry blossoms as a seasonal symbol to represent "starting a new life" and "coming to Tokyo." I also added a hint of what position magic holds in this story's world setting. As a prop, I drew a sign alluding to the prohibition of magic (although it's not very prominent in the final version). At this stage, I'm just adding necessary elements, so I didn't worry about exact placement.

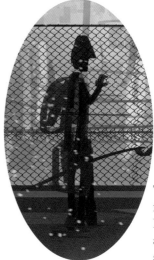

The protagonist's face is not shown. I feel that this sets up anticipation for the start of the story.

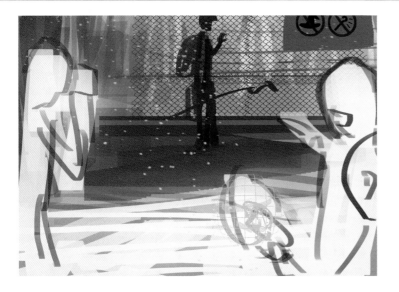

Magic users are rare in the city. As part of this world setting, I placed minor characters in the foreground to frame the protagonist. The lighting is darker only for the protagonist in order to convey a sense of helplessness and isolation.

2 Breaking Up Regularity

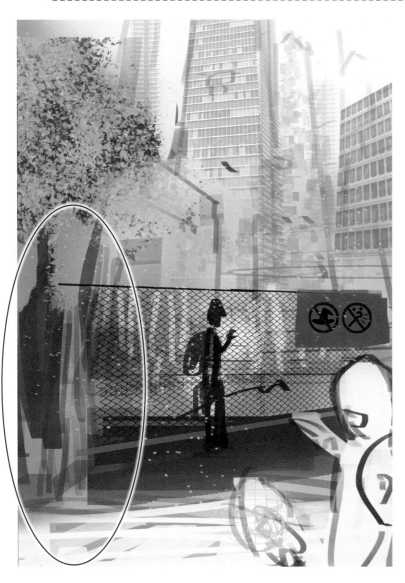

I felt that the composition was too symmetrical and lacked interest. I therefore removed the left-hand side minor character and slightly angled the horizontal line of the top of the fence to elevate the left side of the picture. This reduced the impression of having precisely arranged crossing lines (corresponding to the bisectional composition reference lines).

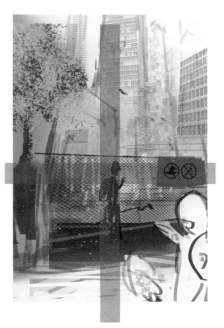

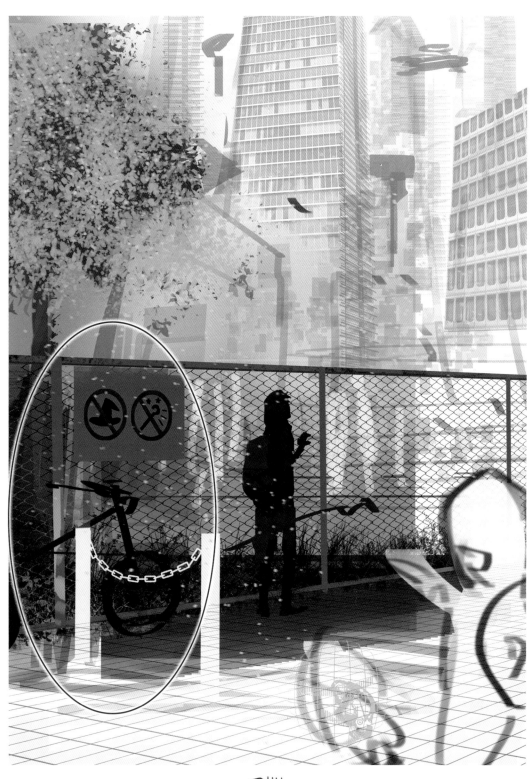

From a narrative perspective, I wanted to more strongly emphasize the sense of the protagonist's isolation. As a metaphor for this, I placed posts where the minor character had been. I added chains to create a feeling of alienation.

The fence, posts and chain to the left and behind ... it makes it feel so closed in. My poor master, it's hard to see him as an outsider.

That's right, I forgot— he's your master, isn't he? I can't believe that.

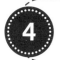

Adding Details and Checking the Composition Once the Elements and Rough Placement are Decided

At this point, I've decided the placement of objects and the character elements. This is to express the concept of the illustration and the story's world setting. From here, I draw the objects in detail.

I've filled in the grid-lined street, the minor characters, the posts, and the grass near the fence—all elements that are close to the camera. The impression of the whole image is now more solid.

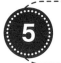

5 Altering the Physical Size of Elements for Stronger Impact

Thinking Outside the Box to Create an Effective Composition

I decided I wanted to show the back view of the despondent protagonist. I enlarged the figure, somewhat ignoring the relationship of size between the person and the structure. I made his body larger without changing his standing position, so naturally it makes him taller. I'm deliberately bending the truth.

6 An Element's Angle Changes the Impression It Makes

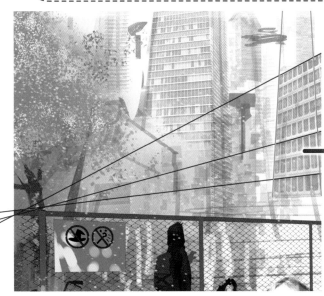

before

after

The protagonist is a magician. I thought about how to easily convey his identity. I changed the angle of his staff so that it stands out.

In fictional works, weapons are another important factor in creating presence. Even a small change in the angle can have an effect.

7 Distinguishing Between Fabrication and Reality

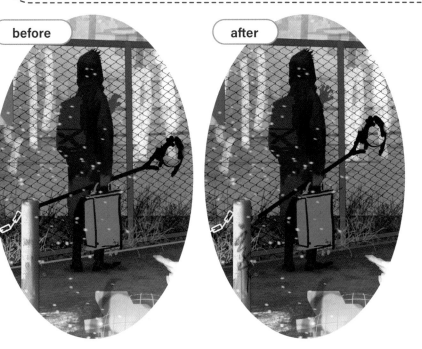

I noticed that the perspective of the background structure made it appear as if the viewer was looking up at it from a closer distance. I tried changing it so that it was as realistic as possible. A small amount of fabrication in a picture is fine. But when a perspective has obvious incongruities, it 's better to adjust it so that it's consistent.

The cherry blossoms have changed too, from a placeholder sketch to a detailed depiction. It suddenly all looks different.

That's because highlights have been added. In step ⑤, details were added to the area around the protagonist's feet. So now the top half of the picture has been adjusted. Details shouldn't be too concentrated in a single area.

8 Keeping Details in the Same Placement as Consistent as Possible

before

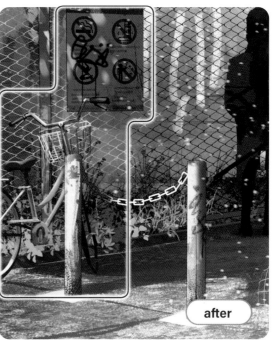

after

I continued by drawing in the signs and the bicycle. As they are close to the camera, I made them as detailed as the protagonist.

before

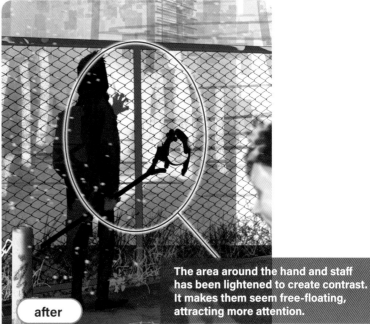

after

The area around the hand and staff has been lightened to create contrast. It makes them seem free-floating, attracting more attention.

It's not just the face that expresses feelings. Hands can convey them too. That's why a small gesture can become a rich expression of emotion.

I made the background of the section of fence that the protagonist is gripping lighter. Creating this contrast means the protagonist's hand can be seen clearly, conveying his feelings. I wanted the staff to be more visible, so I also lightened the background there to create contrast.

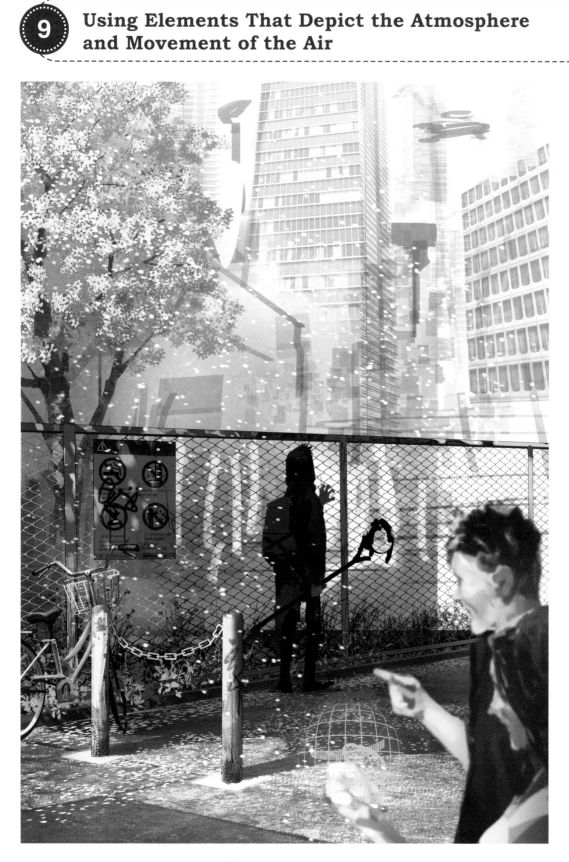

Evoking Senses in a Picture—Adding Dynamic Elements to Suggest Scents, Sounds, Etc.

The cherry blossom season offers an indescribable feeling of anticipation and has a certain atmosphere, scent and energy to it. I wanted the viewer to sense a reality and nostalgia beyond just the visual. The blizzard of cherry blossoms depicts the strong breeze that blows in springtime. The petals that have fallen to the ground express melancholy and an uneasy feeling.

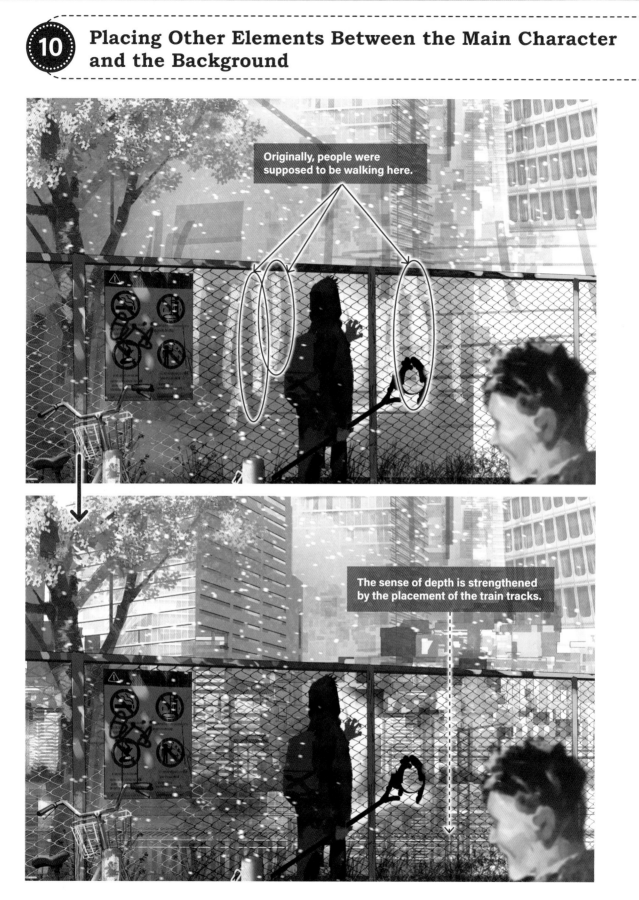

Here, I've drawn the protagonist's dream city. I've made the background image as lively, varied and noisy as possible. At first, I drew a dream cityscape just beyond the fence.

Then, I changed my mind and tried placing large train tracks between the buildings and fence. This created a sense of distance, which accentuates the sense of loneliness apparent in the protagonist.

11 Creating Distance to Increase the Sense of Depth

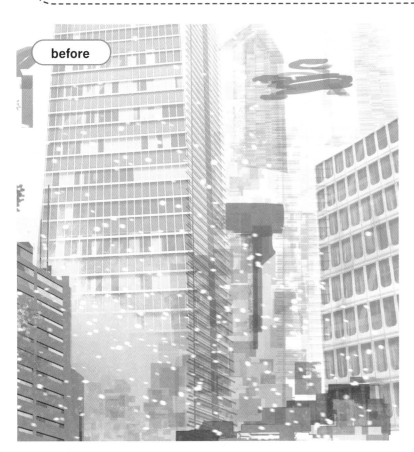

before

after

With the aim of creating atmospheric perspective, I tried slightly blurring the background. I specifically adjusted the colors along with the contrast of color tones for the whole picture. This was to create a sense of distance without changing the shape of the buildings. The city buildings in this picture convey an opulent image. I wanted to keep that grandeur. In other words, I wanted to make them appear distant without reducing their scale.

My changes resulted in a slightly hazy, mirage-like depiction. I did this because the protagonist, who will struggle to reconcile the difference between anticipation and reality, is gazing at the city of his dreams—I thought it would be boring if it looked too realistic.

The buildings to the right and at the rear are modern, aren't they? And in particular, even though the buildings in the distance are now fewer in number, they have a much stronger presence.

It's not necessarily about realism, it just gives an impression of being kind of smooth and flat. That black frame around the low building on the right has the effect of narrowing the field of view when you look at the whole picture. When it's combined with the dark shadow of the cherry tree, it's as if your gaze is pulled toward the center of the picture.

Even though the depiction is inherently vertical, the composition makes it feel even more slender and tall. It's an amazing combination, isn't it?

12 Contrasting Shadows Create Even More Distance

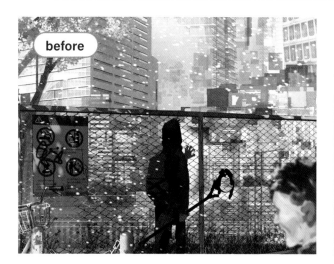

before

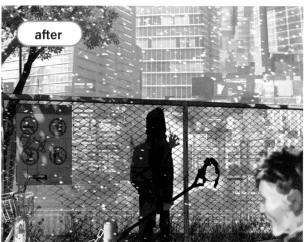

after

In the previous step, I blurred the buildings to make them seem more distant. However, I wanted to create an even stronger sense of distance, so I brought the protagonist's surroundings closer to the camera (viewer).

I created relative distance by adjusting the contrast of the shadows to shorten the distance to the camera.

The closer an object is, the stronger the difference is between the light and dark areas.

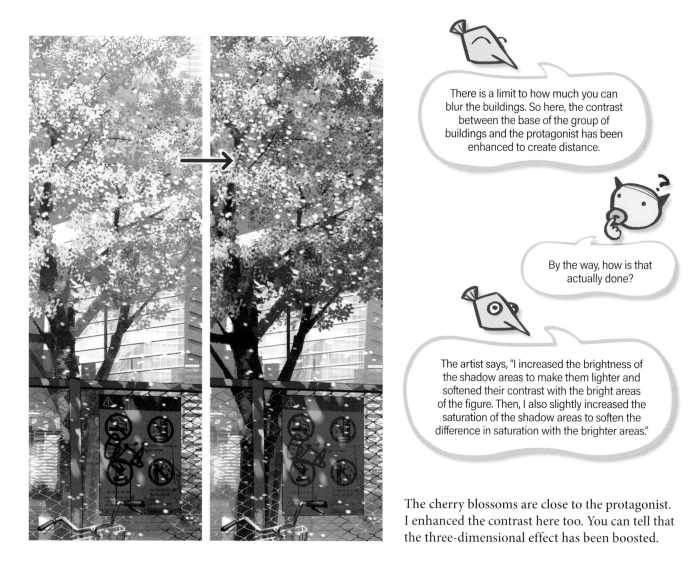

There is a limit to how much you can blur the buildings. So here, the contrast between the base of the group of buildings and the protagonist has been enhanced to create distance.

By the way, how is that actually done?

The artist says, "I increased the brightness of the shadow areas to make them lighter and softened their contrast with the bright areas of the figure. Then, I also slightly increased the saturation of the shadow areas to soften the difference in saturation with the brighter areas."

The cherry blossoms are close to the protagonist. I enhanced the contrast here too. You can tell that the three-dimensional effect has been boosted.

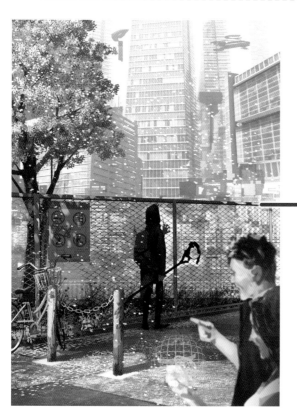

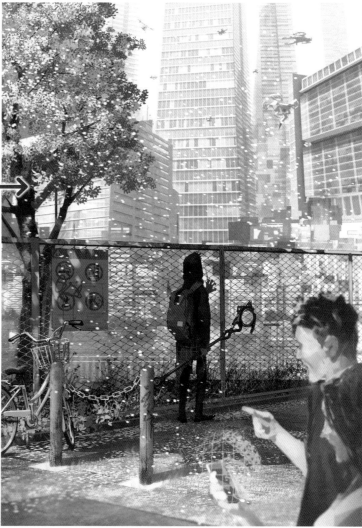

Up until now, I've tried various techniques to express the protagonist's identity and emotions. But there is still too much of an upbeat impression in the image. So, I adjusted the color tone to a slightly cooler one. The work is now complete.

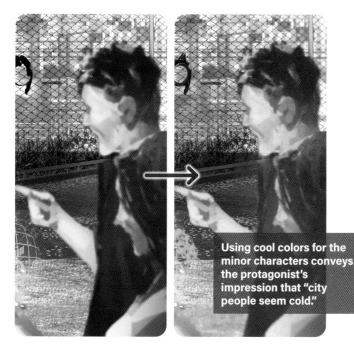

Using cool colors for the minor characters conveys the protagonist's impression that "city people seem cold."

"It's about expressing what I want to convey in this picture. This is achieved through a balance of reality and fiction throughout the whole process."

I thought realism would be the way to go as far as the perspective of the composition is concerned, so I'm surprised that the sizes and sense of distance are mostly made up. When you express something, you shouldn't compromise. If you have to fudge things, you should go all out!

Explaining the Basics

All about elements—it's not enough to just place them arbitrarily. You now know the criteria for placing elements in the picture, but how do you choose what to actually place? You may think it's okay just to position characters and buildings, etc. as appropriate. But there are tricks to making something eye-catching!

What Exactly are Elements?

The elements are all the things that form a picture. This isn't limited to large items like people or objects—even simple dots and lines can be elements. In technical terms, these are referred to as "objects" or "focal points." I will start by explaining the nature of the most basic elements—dots and lines.

The Nature and Role of Dots and Lines

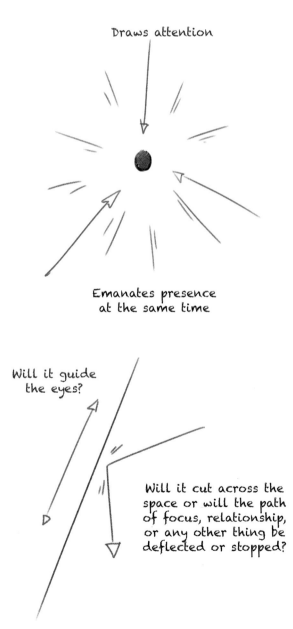

Draws attention

Emanates presence at the same time

Will it guide the eyes?

Will it cut across the space or will the path of focus, relationship, or any other thing be deflected or stopped?

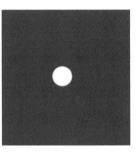

Dots are omnipresent in a drawing. A large number of dots can be combined together to form a mass in order to express various things (elements). When dots of the same color are combined, they form the appearance of a surface. If a color distinct from the "surface" stands alone, it becomes an element recognized as a "dot." In the diagram to the left, a black dot is present on a white surface. In the diagram above, a white dot is present on a blue surface. These dots are eye-catching, meaning they are emanating presence as dots.

If a multitude of dots are collected together, they become a "surface." What happens if they are aligned in a row? That's right—they become a line. A line does not have to be just a single solid line or a straight line, it can also be a line or curve that forms a boundary between two colors. A line is a row of dots, meaning they have continuity which the viewer's eyes can follow. This is what gives a line its power to guide the focus.

People (Characters) as Elements

Face

High

Level of
attention

Low

Here, we'll think about people, which is probably what you are most interested in depicting. Let's look at a person as an element. It goes without saying that a picture of a person is a collection of dots and lines. The area that gets the most attention is the face. Humans are organisms that communicate using their eyes and mouth, so the viewer's focus is drawn to the face where the eyes and mouth are located together. When you look at the drawing above, you will naturally observe the eyes and mouth first.

Building on the previous section, the eyes are essentially large dots and the mouth forms a line, both of which are elements. But that is not the only part of the body to which the viewer's gaze is drawn. The face and head are seen as one large element, with the eyes and mouth drawing particular attention. Size and placement are also important factors. The diagram above has color-coding that indicates the approximate level of attention given to the various elements. The red areas can also be made to be seen as dots.

Line of sight

Guides the direction of the viewer's gaze

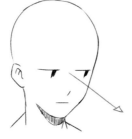

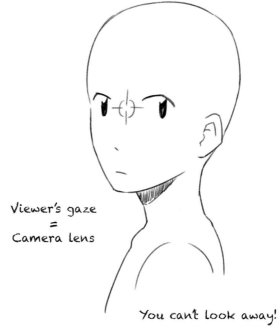

Viewer's gaze
=
Camera lens

You can't look away!

Our brains are finely attuned to process visual information. By looking at the position and direction of the pupils within a face, we can roughly determine where they are looking. The disadvantage to this is that a person's gaze in the drawing will guide the viewer's gaze. That viewer's gaze, having been first drawn to the person's face, will then follow the direction of that person's line of sight.

Even when not facing forward, if the person in the picture is looking at us, the viewer's gaze will fix temporarily on the eyes. This is a line of sight directed at the camera. This is an extremely powerful effect, and in many cases the design requirements for pictures and photographs used on the covers of periodicals specifically call for this camera perspective.

Whole Body

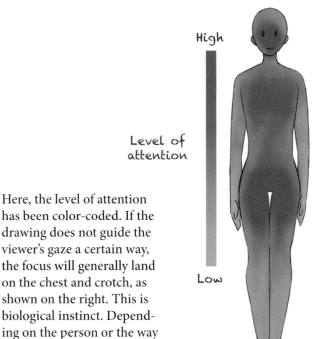

Level of attention

High

Low

Here, we have the whole body. Needless to say, the face is the first thing you see. Then, you look at the expression on their face. Where do you look next? Most people have sexual preferences and so different people will have their attention drawn to different parts of the body.

Here, the level of attention has been color-coded. If the drawing does not guide the viewer's gaze a certain way, the focus will generally land on the chest and crotch, as shown on the right. This is biological instinct. Depending on the person or the way the picture is drawn, more attention may also be drawn to the hands or feet.

For character illustrations, I think bust portraits in particular are visually attractive. This is because they include two elements of interest when placed in the picture—the face and chest area. In addition, the size is neither too big nor too small proportionally for the area of the picture. It leaves a strong impression without needing to move the viewer's gaze around too much. That's why bust portraits are so popular.

Main element = Character

Major elements = Face and chest

Most men are drawn to breasts, aren't they? It can't be helped.

So, even though you're a spirit, you like human women?

That's not what I meant! And anyway, there are many women who like men's chests!!! It's just how it is!

(What's with him?!)

The Nature of Other Tangible and Intangible Elements

Buildings

Implements

These act as an extension of the human body and symbolize the character. Compared to other elements, they have a strong presence. Particularly, those with a recognizable use make an impression—when one appears in a scene, it reminds the viewer of that tool's role in the story.

These can be regarded as a symbol of the human world. The structure style and building materials used represent regional characteristics and the degree to which a civilization has developed. It's preferable to choose those that match the world setting. For sci-fi and fantasy, buildings and tools are a dependable way to convey an exotic setting or fictional elements.

Text

Natural Objects

When text is incorporated into illustrations (aside from headings and captions), it can be used to symbolize human civilization. It's very eye-catching because it triggers the human compulsion to try to read the writing.

Natural objects express regional and seasonal characteristics. Illustrations that reflect knowledge of geography (topography and geology) and environmental science (flora and fauna) are much more convincing.

Dots and Lines

A beauty mark modifies the "eye" as focus point

The center of the light is the focus point and the rays of light form borderlines.

Dots and lines that act as decoration are all elements. Specifically, sources of light, effects and other elements that affect the picture can change the strength of an impression. As explained on page 78, lines that cut across a surface have the power to segment space and the ability to guide the viewer's gaze. Every dot and line, like a seam in the concrete or a crack in glass, has an effect on the viewer's gaze.

2-2 Space Gets Created When Elements are Placed!?

A picture without visual cues will just appear flat. This can be a major issue if you don't know how to create depth. So, let's try some placing of elements. Even with just two, space can be created.

Positional Relationship of Elements

I have placed one person standing.
At this point, by adding a shadow being cast at the feet, it creates a light source and the ground. While there is a top (light source) and bottom (shadow), there is no depth. A space has definitely been created. But it is still unclear how much space there is in the picture.

Here, I have two people standing.
The shadows are horizontally aligned, showing that the figures are side-by-side. While there is no depth, at least a definite width (distance) has been created. Their lines of sight meet, confirming once again they are next to each other.

Now, I have changed the size of the two people. The person on the left looks farther away, right?
This type of perspective method is known as "linear perspective," where things that are farther away appear smaller. The person on the right seems to be looking at the person on the left, so even if the ground is outside (below) the picture, we can still perceive that they are meant to appear to be standing on the same horizontal plane.

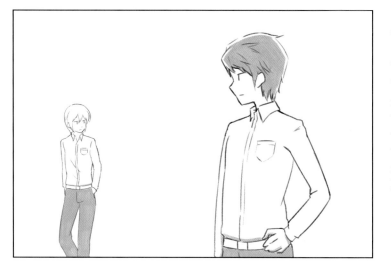

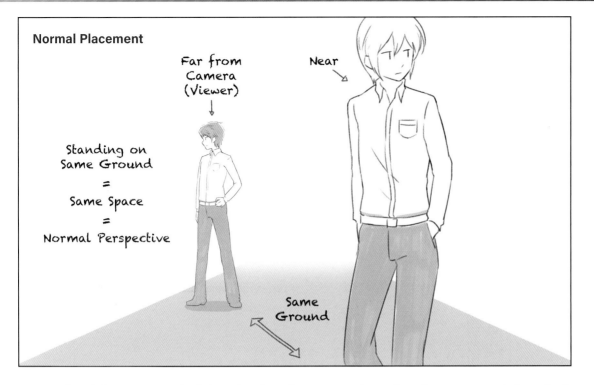

Normal Placement

Far from Camera (Viewer)

Near

Standing on
Same Ground
=
Same Space
=
Normal Perspective

Same Ground

Here, I placed the person on the left so that their feet are in the picture. Although the individuals' lines of sight aren't meeting, because the ground is pictured, you can recognize that they are in the same space.

Once you understand that they are on continuous terrain, it becomes easier to decide how and where to place other elements around them. In the case of the illustration above, if the ground is flat, it would be good to have a tree growing or a building standing on the same ground. Conversely, if there's a change in the terrain, you could make it rise or sink down from the ground already present.

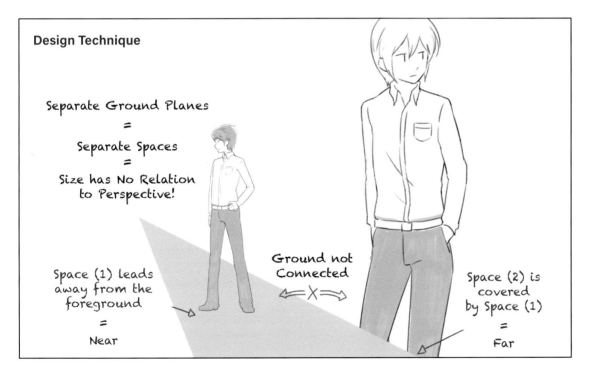

Design Technique

Separate Ground Planes
=
Separate Spaces
=
Size has No Relation to Perspective!

Space (1) leads away from the foreground
=
Near

Ground not Connected
⇐X⇒

Space (2) is covered by Space (1)
=
Far

The placement of the people is the same as in the illustration on the top of the page, but only the person on the left is shown making contact with the ground, while the feet of the person on the right are covered by that ground. This is a technique used in key visuals and character illustrations and represents a method of drawing that ignores spatial consistency. If you draw pictures using a computer, you understand the concept of layers. I superimposed the space (layer) of the person on the left on the space (layer) of the person on the right. This has the effect of making it seem like the person on the left is closer to the camera.

Enlarging or Grouping Elements Together

The person on the left occupies a smaller area, or proportion, of the picture. This figure can be considered to be a "point," while the larger figure on the right can be seen as an "area," or what is referred to artistically as a "mass" or "focal area." The larger figure draws the gaze more easily and seems to be closer to the camera. This difference in impression is due to linear perspective.

However, with linear perspective, the person on the left should appear to be farther away. However, that is not how it looks in the drawing on the right. This is because there are no depth cues in the picture, and the person on the left is looking up at the person on the right. To depict figures of the same size with a sense of depth, it's necessary to align the depth of the ground and the background with the height from the ground corresponding to the angle of view.

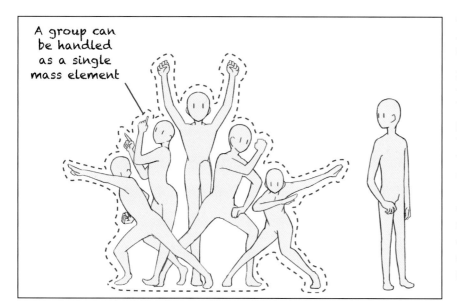

A group can be handled as a single mass element

This drawing has a group of five people of approximately the same build. Away to the right is a single individual, lined up horizontally at the same distance from the camera. When a large number of people are grouped together to form an "area," this functions as a background. From that perspective, this group of five can be treated as a single "area."

Unlike the so-called "area" of a crowd though, these five people are clearly eye-catching. This is because each of them is striking a pose and each has their own characteristics, so this pulls in the focus.

The image above is similar to the third one on page 82 in that there are effectively two elements of different sizes, and you can see their feet and one is looking up and meeting the other's gaze.

By the way, why ARE the 5 people in the bottom picture posing like that?

There's an optical illusion like this, isn't there? Even though the people are the same height, they appear to be different sizes because of the height of the ceiling and floor, as well as the distance from the camera. It's maybe like that.

Differences in Impression for Each Element

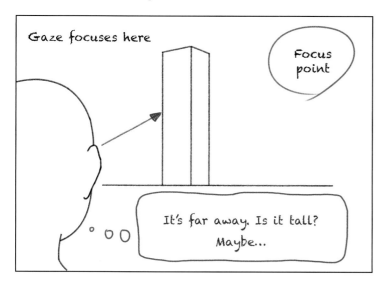

I drew a tall building in the center. Psychologically, it gives the impression described in the illustration. People focus on the one tall building in the distance and observe it carefully.

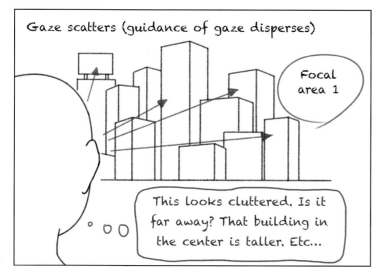

Here, I grouped a lot of buildings. They vary slightly in terms of height and width, but apart from size, there are no other outstanding features, unless you count the billboard on the left.

In this way, it is treated as an "area" when focusing the viewer's gaze. If the gaze isn't guided, the impression will be scattered. This is the same kind of impression that is created by a forest, as opposed to that a single tree.

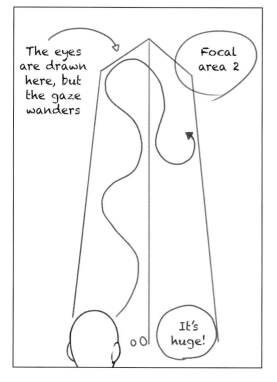

As the building takes up practically the whole canvas, it gives it a sense of immensity. It catches the eye, but it's difficult to know just where to look. Now, imagine moving the viewer closer in toward the building. This results in it becoming just a wall and because the outline can't be seen, it's like a single background or pattern. Depending on how close you get, you run the risk of losing the grand sense of scale too. The larger the proportion of the object in the picture, the greater its presence will be. However, remember that the primary goal is to draw in a way that achieves the desired effect.

The Rule of Three

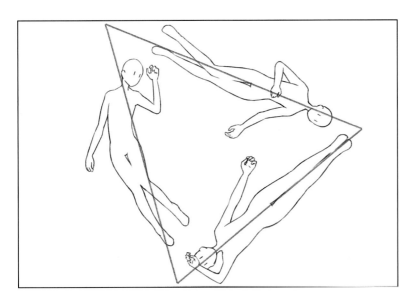

There is a concept often described as the "rule of three." Steve Jobs frequently made mention of three points in his famous presentations.

The number three is very important in the world of illustration too. It can refer to the number of elements, the range of sizes, the levels of depth or steps for guiding the viewer's gaze.

A triangular composition is a particularly good example of this. Within a rectangular frame, the balance of the elements can easily be lost. Therefore, it's easier to guide the viewer's gaze using this method.

So what happens if there are only two people in the picture? It's not always necessary to follow the rule of three. If there are three elements somewhere in the picture, it makes the communicated visual information more impactful. For example, as shown in the image to the left, what if the leftmost person's figure is seen as a single focal point and the rightmost person's face and chest form the second and third focal points? It would direct the gaze in a triangular motion.

Next, we look at the case where there are four or more people. This uses the principle mentioned in the previous section. Two or more people can be grouped together to form a single element. Things in the distance become less prominent, so if there's depth in the illustration, it's easier to place groups of people deeper in the field of view. If you want to draw them all the same size yet individually, consider varying the terrain within the frame or using creative posing to achieve the desired effect.

Levels of Depth

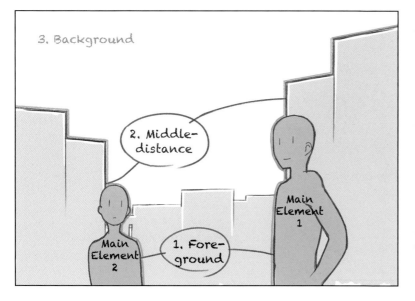

Let's discuss the rule of three in relation to background. In most cases, three levels are used for depth—foreground, middle distance and background.

If you place an element closer to the viewer than other objects in the foreground, its prominence in the frame will be distorted. In addition, it gives the impression that unnecessary items are intruding. However, it depends on the composition of the picture, so this is not a hard and fast rule.

Placing elements beyond the plane of other objects in the background isn't very effective. For instance, placing the moon, stars or buildings even farther away than a cluster of distant buildings. This is because they would all register as a single element.

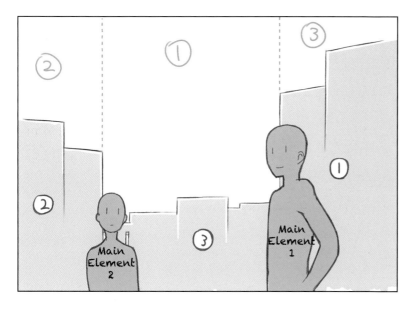

It's also preferable to have three steps for the ratio that elements take up in the picture. The density of the shading is important in a picture and if there is no corresponding amount of "negative space" it is difficult to guide the viewer's gaze. Ideally, the gaze should first be drawn to the main element ❶, guided on to the secondary main element ❷, and then back to main element ❶ through the middle distance and background.

Moving the path of focus from the main element ❶ to the secondary main element ❷ means that depth has already been created. So, as is the case in the image on the left, it is ideal to place elements in order for the gaze to move through to the far distance. For example, you could use an airplane, bird, or cloud that has right-to-left directionality.

Lastly, this image has actually been composed with the assumption that text or a logo will be placed in the top left area of the frame. Elements that are important to the work shouldn't be used where they will be hidden once a logo or text is in place. If the elements in question are important to the story, you will need to adjust the composition to accommodate each element.

The rule of three is like the golden ratio. There's no scientific basis for it, but if it looks good, who can argue against it?

Yeah. This is the hardest one to understand. I don't know as much as you do about human perception, so I defer to you!

Why Divide Up the Picture?

Sky

Sea

Sand

Borders defined by contrasting hues and tones

From here, let's look at lines and spaces that cut across the picture.

When we say "dividing up a picture," it means separating areas.

The image on the left shows a simple drawing of sand, sea and sky.

Everything is in the same frame, but there is clear separation of foreground, middle distance and background. Even if this was a black and white manga, there would be clear boundaries between the near-black sea, the almost-white sky and the gray-toned beach. Solid lines don't have to be drawn as the space can be divided by differences in brightness and hues.

Here, I tried breaking up the picture with a solid line. The left and right are completely different spaces.

This is a manga or cinema style of dividing space. In manga, the pictures are divided into frames with solid lines. In videos as well, there is a technique of dividing the screen into two or more sections showing different scenes at the same time, and those are usually defined by solid black lines. It's fine to use this technique for illustrations as well. However, it can often give a sharp, manga-like or cinematic division that may not be suitable for the illustration.

I've changed the solid line to a sword here. We can still understand that the left and right spaces are different, but there is no longer a sharp line of division. There is also the symbolism that the sword holds significance for both of the pictured individuals. This can also be used in videos where the scene is always moving or in manga where the story is shifting, but it can't be used very often. In a standalone illustration, this way of dividing space is effective as a gimmick.

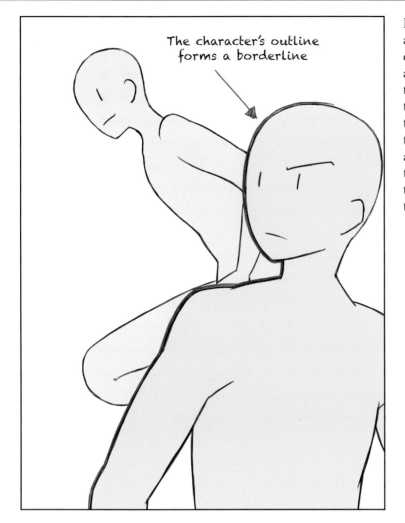

The character's outline forms a borderline

In this image, instead of using solid lines or an artificially-introduced divider, I have placed one person behind another. Their proportions are different, so it's clear they are not standing together on the same ground. In other words, the person in the foreground and the one in the background are in different spaces. So here, the outline of the person in the foreground is acting as a borderline. We can also understand that there is a relationship between the two, not through use of an item like a sword, but because they are exchanging looks.

This is the method used for the cover illustration of this book!

Thinking about the image to the left, the protagonist and the heroine have the same positional relationship in the foreground (refer to page 25). It's interesting that even though they're grouped together, they're each in a different space.

Even within the same space or on the same plane, borderlines can be created to give meaning. In the example to the right, the block wall is continuous, demonstrating that the characters occupy the same plane. But there is a single utility pole standing between the characters, forming a borderline.

In this example, there is some kind of emotional distance or barrier separating the pictured individuals, and the pole serves as a metaphor. To sum up, dividing up the picture leads to separation of areas, the dividing up of space, and creating a sense of distance.

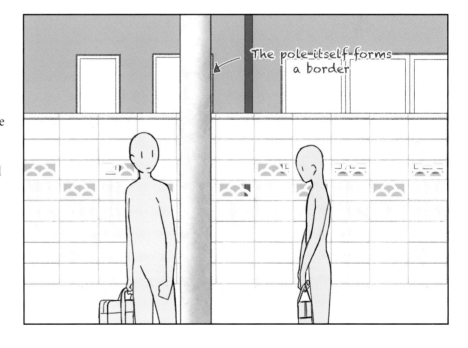

The pole itself forms a border

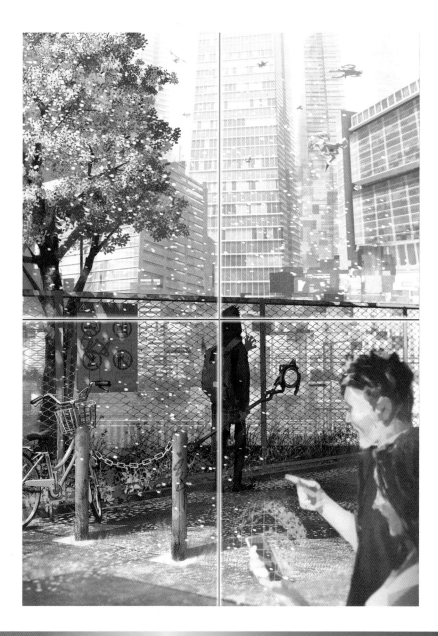

Taboo: Things Not To Do

This book includes several artistic techniques that are deemed to be taboo. A prime example of this is the illustration "Cross" in Chapter 3. The fence divides the picture in a straight line and the building and character are placed almost in the center. However, this composition has a clear intention. The fence represents "the wall around the character's heart," and the building symbolizes "the fantasy the character has longed for." My aim was to create an illustration to express these metaphors, despite the risk of the placement being "taboo."

I can of course understand when someone asks me to teach them techniques that are regarded as taboo.

However, the essence of art is "if it feels right, it is right." An illustration isn't fine art, and it's not a photograph either. So rather than avoiding methods considered "wrong" and feeling more and more constrained, I want you to pursue what you feel to be a "right" picture. That's why in this book, I've intentionally avoided mentioning taboos in any chapters.

Conveying your intentions to the viewer and steering them toward what you want them to focus on is what matters. Enjoy drawing freely and creating your work. That is what will lead to a truly great composition.

Chapter 4

Capturing an Important Action Scene in a Story

With the characters and world settings firmly established, the next step is to portray an action scene. This are scenes in which a character confronts their enemy or rival: a fight! Everyone wants to show off their cool characters in a stylish manner. Let's see how the pros compose such scenes.

Concept Art That Conveys the Atmosphere of the Story

A monster suddenly appears and the protagonist confronts it. Everyone wants to draw a powerful battle scene like this at least once, right? But even so, you may not know where to begin. For those of you in this situation, this example will be useful. This chapter is packed with ideas for creating and building tension.

Title: Unite

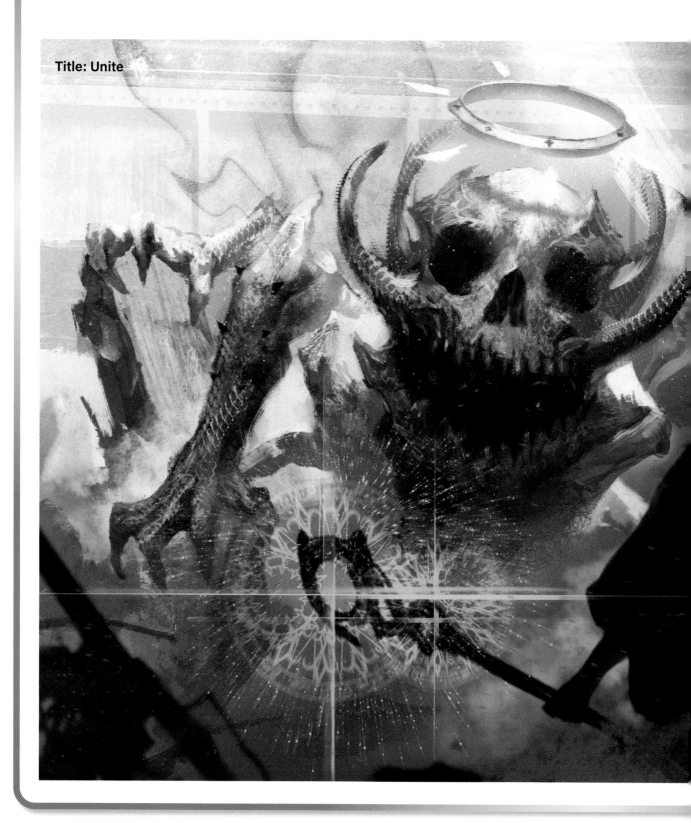

Refer to page 23 for the illustration's world setting and background story.

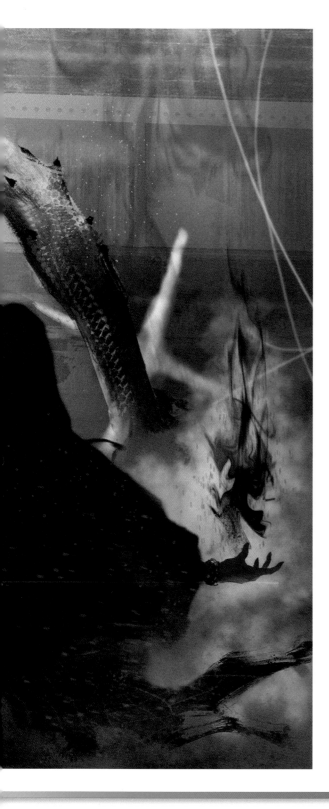

What I Want to Convey in This Picture

Creativity and Realism

I draw fiction that is close to the real world.

In this case, getting the right balance for how much realism to add and how much creative fantasy to inject into the scene is the challenge. Moreover, it's important when including unrealistic elements like magical warfare to compose a scene that has ordered priorities.

When creating this picture, I compared various general images of modern fantasy worlds and focused on keeping the realism consistent.

The Protagonist's Inner Struggle

The setting is a society where magic use has greatly diminished. This results in the protagonist, who is skilled in magic use, being marginalized by society. It is under these circumstances that he encounters a monster. This creature, considered to be a threat to society, becomes a presence that affirms the raison d'être for the protagonist. Bearing both his own and society's turmoil within him, the protagonist confronts the creature.

For the composition, I shifted away from my own theories a lot. The story itself took center stage. Even so, I'm happy with the resulting unique piece that successfully conveys my intentions.

(Commentary: Rui Tomono)

Production Requirements

Concept Art

Concept art is a drawing used in the early stages of production for a game or animation to convey the actual atmosphere of that work. It is also called an "image board." During production, a variety of scenes for the work are drawn, with the purpose being to propose and develop the overall look of the work.

Realizing a Unified Level of Realism in Individual Images and Scenes

In the previous chapters, I created the cover illustration and "Cross," the scene where the protagonist comes to Tokyo. With those accomplished, my goal here is to draw a battle scene that is convincing, intense battle scene while maintaining a unified sense of realism.

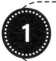

Aligning the Protagonist's and the Viewer's Perspective

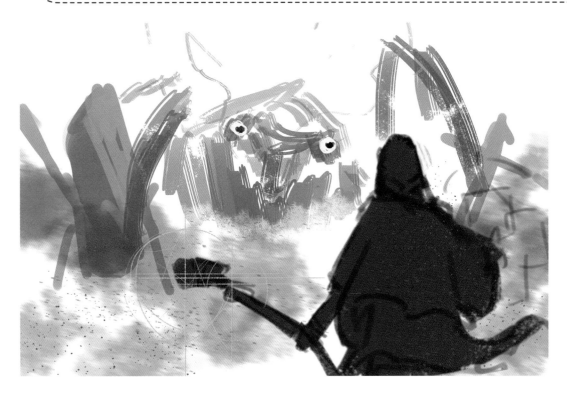

As I was drawing the rough sketch, what I kept in mind first of all was the sense of distance between the protagonist and the creature. I was thinking of a composition that would convey the tension and fear before a battle. So, I drew a rough sketch where the protagonist and the creature are in close, oppressive proximity.

In addition, the protagonist's face can't be seen. This has the effect of the protagonist's line of sight being aligned with that of the person looking at the picture.

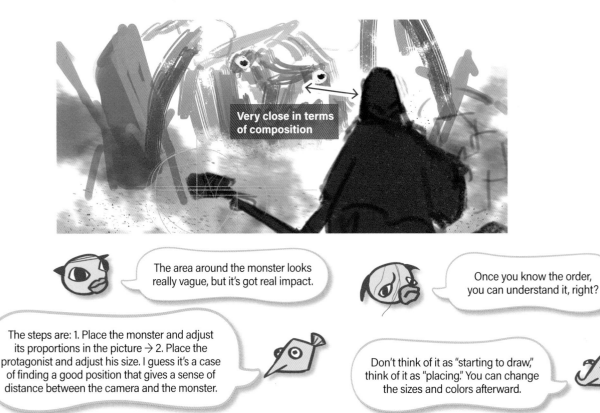

Very close in terms of composition

The area around the monster looks really vague, but it's got real impact.

Once you know the order, you can understand it, right?

The steps are: 1. Place the monster and adjust its proportions in the picture → 2. Place the protagonist and adjust his size. I guess it's a case of finding a good position that gives a sense of distance between the camera and the monster.

Don't think of it as "starting to draw," think of it as "placing." You can change the sizes and colors afterward.

When Really Stuck with Placement, Try Using Reference Lines

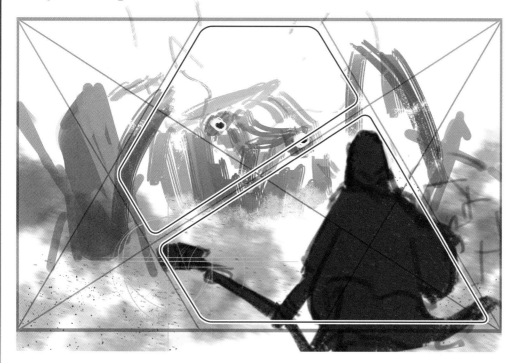

The image above shows the placement of reference lines for the golden ratio (phi grid). The protagonist is almost completely framed within the red lines. In addition, most of the creature's body is placed within the opposite frame in the upper section.

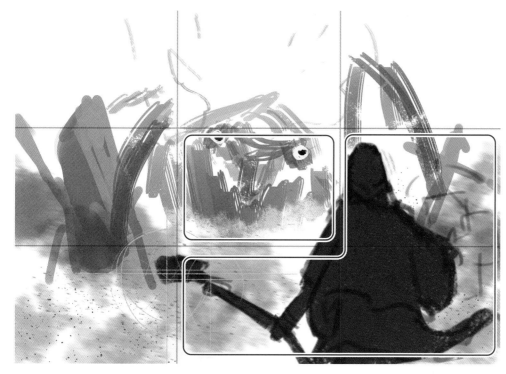

Drawing in the reference lines for the rule-of-thirds composition shows that the protagonist fits in the bottom right third of the picture and is of an appropriate size too. The creature's face is positioned in the center frame, pulling in the viewer's gaze.

(Commentary: Studio Hard Deluxe)

2 Finding a More Appropriate Sense of Distance for Opposing Elements

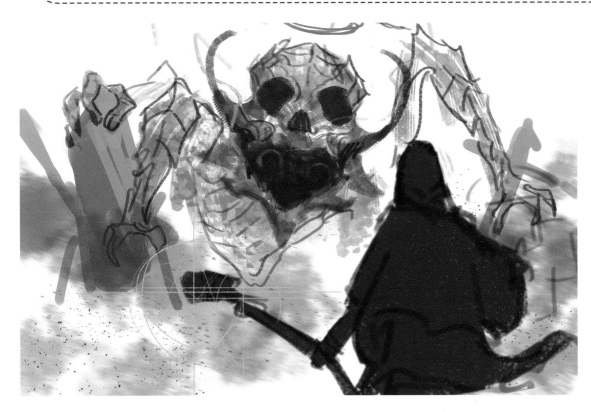

At this stage, I explored how to create a disturbing sense of closeness between the protagonist and the creature, conveying an even greater sense of menace to the viewer. If the rough sketch of the creature is too vague, the area it occupies in the picture can't be set. That means the impression for the sense of distance will differ too. So I took some time to sketch a general design.

Aligning the Line of Sight

It makes me wonder what kind of situation occurred to trigger this confrontation.

Makes you wonder, right? Everyone has different ways of coming up with ideas. It's interesting learn about this process.

The point of reference when I made the first rough draft was a "sense of looming menace." That abstract point was all I had. However, while I was thinking of the creature's design, I came up with the idea of aligning the line of sight between the creature and the protagonist opposing it. I placed eyes within the mouth of the creature and aligned them to the level of the protagonist's line of sight. Doing that created an ominous tension. This idea became a major criterion for adjusting the composition.

3 Thinking About a Composition that Emphasizes the Concept

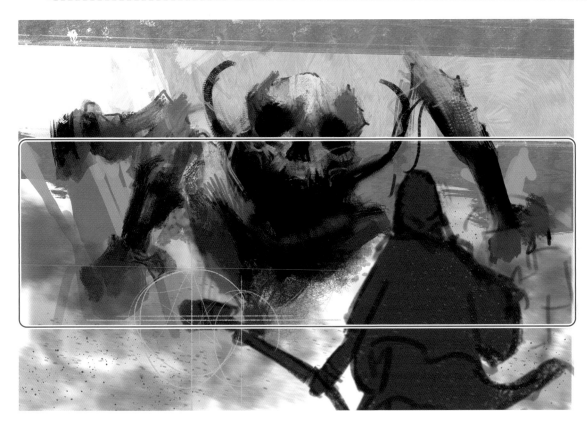

Prioritizing What You Want to Convey Even If the Composition is "Taboo"

I placed a wall in the background and added detail to the creature, which is the main element of this picture. My belief is "there are no rules in composition." But there are a number of taboos I was taught to avoid in art school (such as the lines and areas of elements—walls and effect lines—running parallel in the picture) exemplified here.

The line of sight of both the creature and the protagonist are present within the frame created by the two lines. This has the effect of creating a stronger sense of confrontation. Normally, I would correct this sort of taboo. However, if it serves to reinforce the theme, let's stick with it.

Compositions Usually Considered Taboo

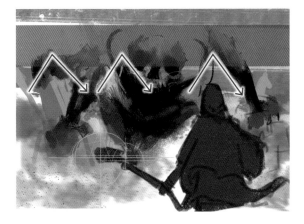

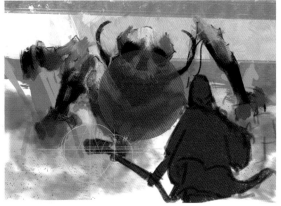

Lines parallel to the edge of the canvas can repel the viewer's gaze, making it difficult to convey a sense of depth. If the main motif (here, the creature's face) is in the center of the picture, it makes it difficult to guide the gaze, and the illustration lacks depth.

Using Lighting to Emphasize the Main Motifs

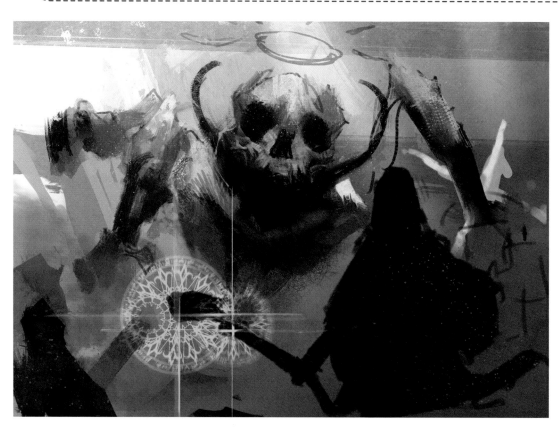

I've now decided the silhouette and placement of the main element. Next, I need to set the lighting to vary the level of focus. I thought first about having light shining on the protagonist and to place the creature in the dark.

Ultimately, though, I felt that there needed to be decisive impact, so I changed the arrangement to have the light shining on the creature.

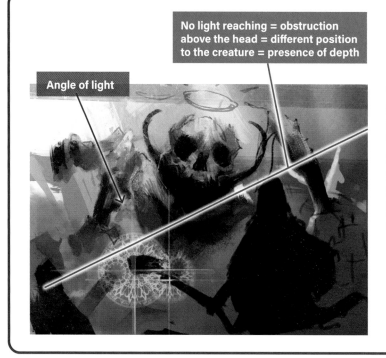

No light reaching = obstruction above the head = different position to the creature = presence of depth

Angle of light

We can tell from the angle of the shadow that light is shining down from overhead. Meanwhile, the protagonist is in shadow. This means there is something blocking the light over his head. Lighting is also a way to emphasize the physical distance between the creature and the protagonist. It doesn't just emphasize elements. It also creates an effect of depth.

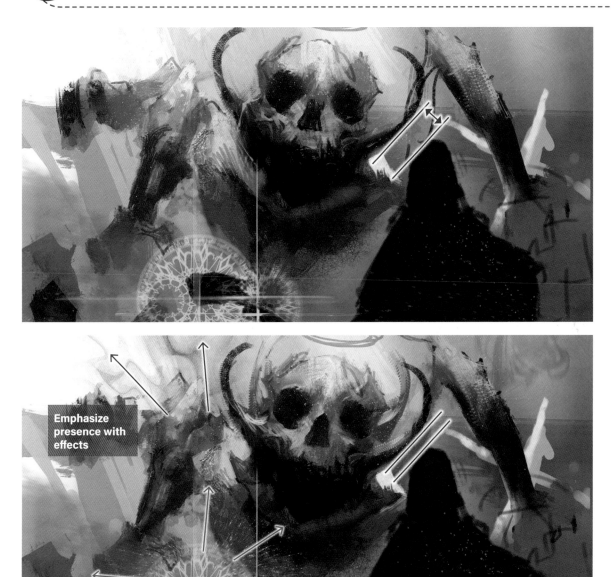

Emphasize presence with effects

Here, I drew in various effects. This conveys the strangeness of the creature and the atmosphere of the setting. I also further reduced the distance between the protagonist and the creature to enhance the sense of menace.

The effects are directed outward, visually emphasizing the presence of the creature and the circular magical sigil.

There was an explanation on page 78 that dots are both eye-catching and emit a sense of presence at the same time. That's what's being applied here.

It's not about randomly having light shining or adding blurring. Effects are elements too. These structural elements of the picture have to be combined and arranged effectively.

6 Eliminating Incongruities That Distract from the Intended Path of Focus

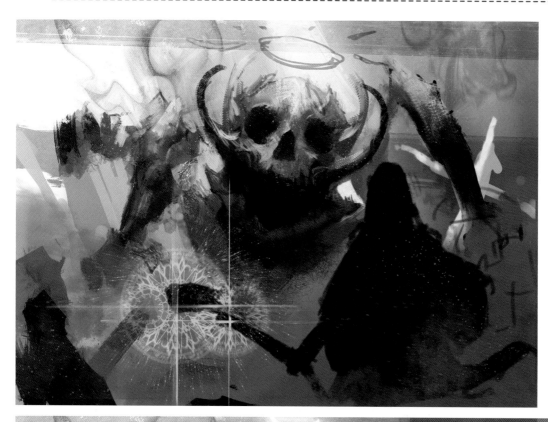

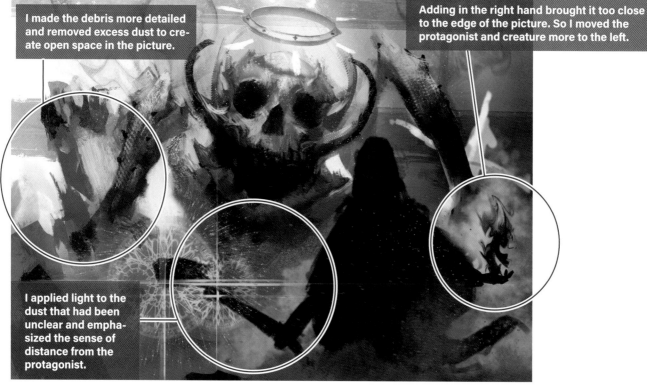

I made the debris more detailed and removed excess dust to create open space in the picture.

Adding in the right hand brought it too close to the edge of the picture. So I moved the protagonist and creature more to the left.

I applied light to the dust that had been unclear and emphasized the sense of distance from the protagonist.

Process the Lines and Elements Placed in the Rough Sketch, and Recheck the Whole Picture

I drew in more details in areas that I'd left vague during the earlier stages, so that things like the debris and dust in the background on the left could be seen properly. I did this to depict the context of the creature and protagonist confronting each other. At the same time, it more clearly defined the volume of the distance between them.

7 Drawing Each Element with the Relationship in Mind

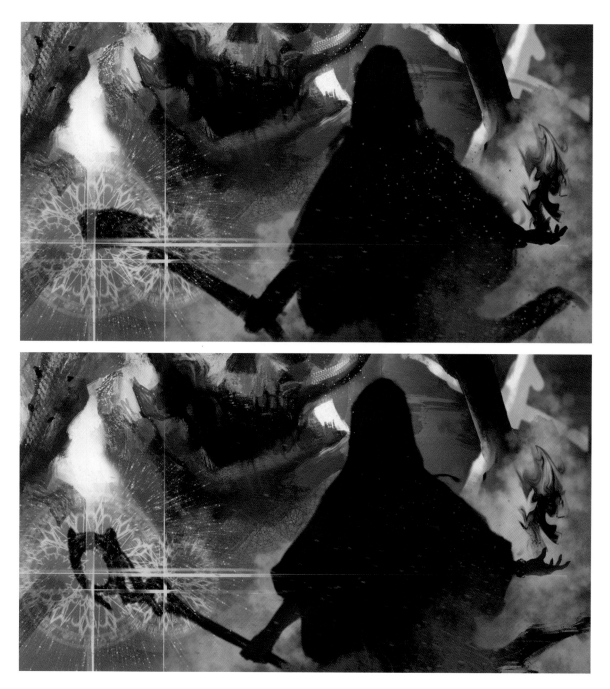

I went on to start polishing up the protagonist, while keeping in mind his positional relationship to the creature. It's not my aim to depict the protagonist as a completely separate element. By drawing the protagonist, the viewer is given information about his distance from the creature. The focus is on the creature, so the protagonist, close to the camera (viewer), is not in focus. Adding too much detail or getting the lighting wrong can skew the sense of depth.

Just when I thought work was going to start on my master, he keeps focusing on the creature...

That's because this composition is depicting a sense of menace. The creature is causing that, so it's natural to have more attention on it. Best to make it clear what it is you're wanting to do.

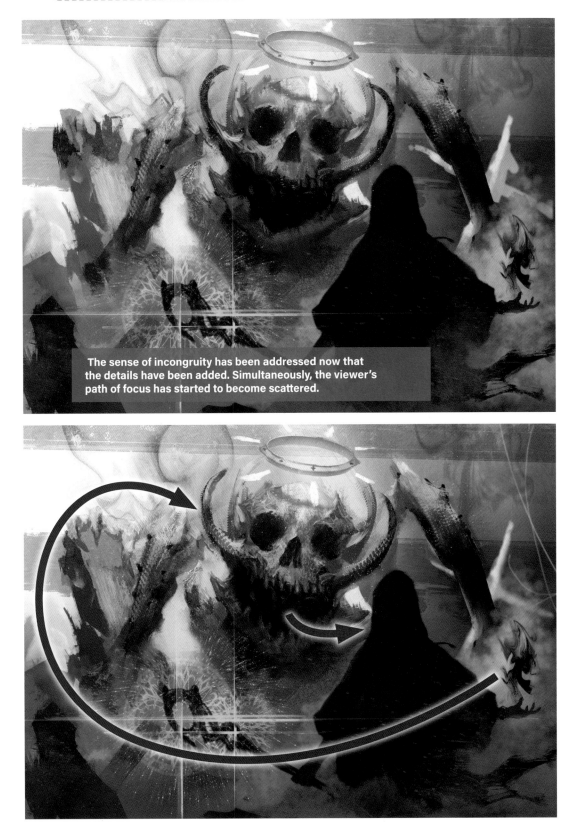

The sense of incongruity has been addressed now that the details have been added. Simultaneously, the viewer's path of focus has started to become scattered.

I used the lighting here to bring together the individual elements, which had been lacking unity. Along with this, I added more details to the creature, restructuring the picture to focus the viewer's gaze on the center.

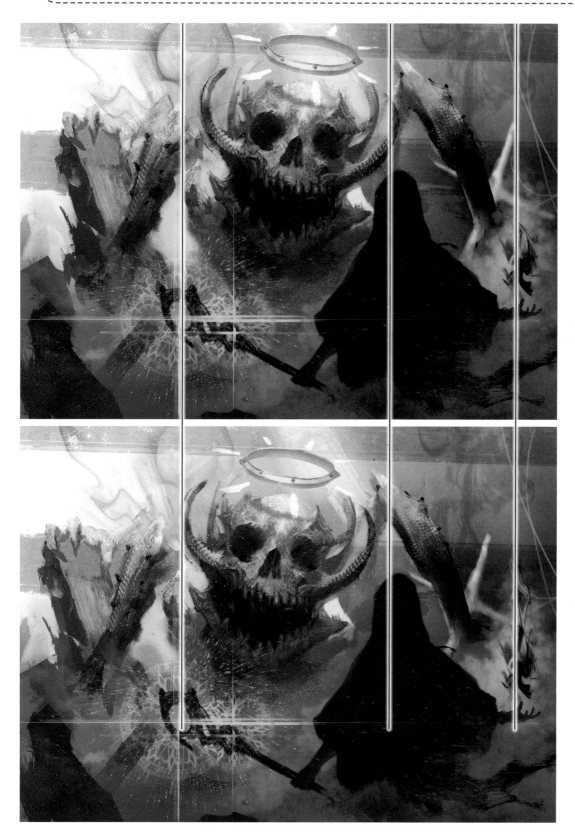

While I let the taboo in step ❸ pass, I wasn't happy with the position of the creature's face, as it was too centered. I shifted its position and slightly reduced it overall. The composition remains essentially unchanged, however.

Using Horror to Heighten the Level of Focus

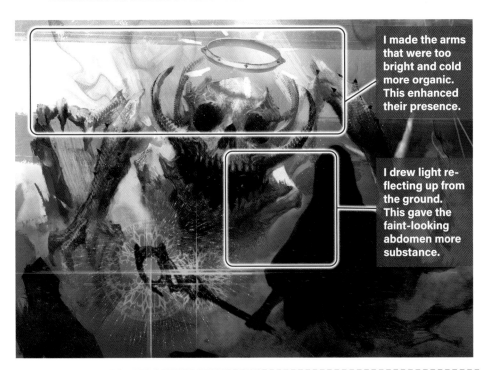

I made the arms that were too bright and cold more organic. This enhanced their presence.

I drew light reflecting up from the ground. This gave the faint-looking abdomen more substance.

While reviewing the picture as a whole, I felt that the realism of the depiction was a bit thin. I felt there wasn't a strong enough sense of horror. So I added more realistic depiction. I increased the amount of detail by drawing in ambient light and realistic textures. Compositionally, this further focused the gaze.

A Blurred Background Creates an Effect Too

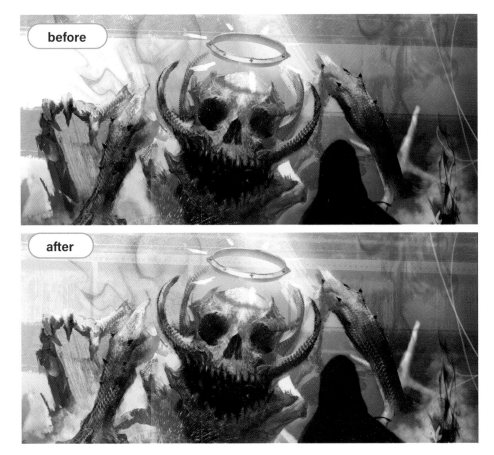

before

after

As with step ⑩, the surrounding areas also lacked realism. So, I depicted the background in detail. Taking a hint from a camera's depth of field, I left the center in focus while adding some blurring to the background. However, this caused the protagonist to appear to float at little. I looked for reference material, such as for construction sites, and added touches of detail around the picture to give the viewer some familiar anchors.

12 Using Lighting to Increase Contrast in the Picture

I adjusted the tone curve to make the light areas brighter and minimized the dark areas. Elements with a strong contrast are eye-catching and make a strong impression. I applied this across the whole image so that the gaze is drawn into the picture itself.

Explaining the Basics

Art is to be seen, so always remain aware of how you're guiding the viewer's gaze. People who draw or who teach drawing often remind us of this. What is meant by guiding the gaze? Here, we'll look more closely at the techniques for how to do that.

3-1 Which Element Do You Want to Make Stand Out?

In this section, I will explain the techniques for making the main character stand out and how to draw focus to them. Why does the gaze need to be guided? It's because pictures don't make an impression just because you look at them. Guiding the gaze of the viewer makes them repeatedly aware of the main character. This is how to leave a lasting impression on the viewer. It can also convey what it is you want to show.

Controlling the Power to Focus the Viewer's Gaze

Size (Perspective)

Increasing the size (in terms of linear perspective, moving the image closer to the camera, as shown on the left side of the image above) creates a stronger impression. Or conversely, reducing the size (shown on the right) softens the impression.

This utilizes the brain's function of looking more carefully at things that are closer. If you put two or more characters in the same space, place them so that there is some consistency with the distance from the ground and the height of eye-level. If not, it will create incongruity. Be sure to make a note this point.

Focus (Sharpness)

The eye will tend to focus on sharp images. That's why if something is in focus (on the left in the image above), it makes a stronger impression. On the other hand, if something is out of focus, it will have weaker impact.

In this case, the point is not to align objects that are in focus and out of focus on the same horizontal plane. Objects placed at the same distance from the camera (viewer) must always have a consistent amount of sharpness.

I'll use the foreground, middle distance, and background to give an example. If the foreground is in focus, it's fine to make the middle distance slightly blurred and the background even more out of focus. If both the foreground and background are in focus, it will look odd unless there is some logic behind it (e.g., if it is an alternate space).

Amount of Detail

The more detailed an item, the more eye-catching it is. This is a common technique for character design in games and anime. In general, the protagonist should have a more elaborate design than minor characters. The greater the amount of detail, the higher the level of focus will be.

In contrast, if the density of those various details doesn't match, it is more likely to cause a feeling of strangeness. For example, if you place a vaguely sketched person next to one who has been drawn in great detail, they won't be considered the same type of character and will feel off, unless it's a deliberate artistic choice.

Omitting details from far-away objects and making closer objects more elaborate is a very effective way to create differentiation.

Number of Colors

This is another technique often used in character design. For a single element, three colors are better than two, four colors are better than three, and so on. The more colors you use, the more the element will stand out. Here again, be careful not to create too much of a gap between the number of colors used for the element you want to make prominent and the number of colors used for the surrounding minor elements. While it will depend to a degree on the saturation and brightness, the more colors you use the more vibrant an element will be. Don't add too many though, as it will make the element seem garish and out of place.

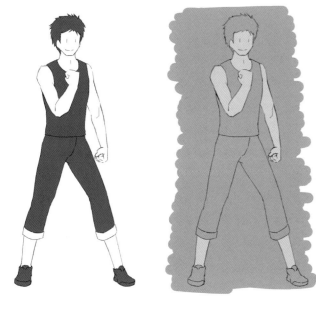

Contrast

Contrast here refers to the differences in brightness and luminance in adjacent areas. This is related to the number of colors, but when objects are placed side by side or in the same setting, the gaze is drawn to the one that has clear differences (shown on the left in the image). Conversely, objects that have similar values of brightness, hue and saturation, with little difference between them look blurry and form a weaker impression (as shown on the right).

This is one of the effects of atmospheric perspective, where the colors are muted for distant objects and made more vibrant for objects that are closer to the camera (viewer). The amount of color muting will depend on the setting's climate, the time of day and the depth to which the elements have been placed in the picture. This doesn't have to be accurate either, so it's fine to fudge things a bit in your illustration.

Using Characters' Sight Lines to Guide the Viewer's Gaze

First, a question: When you look at the image below, how does your gaze move?

The heading says "Guidance by a Person's Gaze," but the explanation is about the surrounding setting and the text influencing how the gaze is guided. Isn't this a misleading heading?

But I did actually find my gaze being drawn from 1 to 2. I didn't care about the picture's surroundings or the text.

Most people will follow the line from 1 to 2 and then from 2 back to 1. As explained on page 79, the line of sight of a person in the picture has the power to guide the viewer's gaze. And if there is another line of sight there, the viewer's gaze will then move in that direction.

But why did your gaze start at the top left? It's because there's a trick hidden on this page. Page heading text is positioned at the top left of a page, so it's the first part of the page that catches your eye. You then keep looking in the same direction as the text, starting from the top left. That's why the majority of people's gaze will move from 1 to 2. Those whose gaze moved from 2 to 1 had their attention subconsciously drawn to the lower-right character's direct gaze at the camera.

Using Background and Brightness to Guide the Gaze

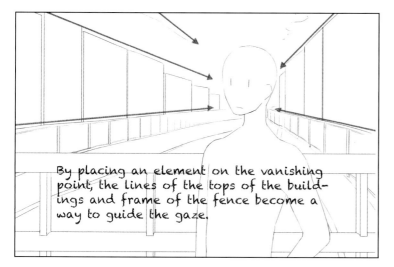

By placing an element on the vanishing point, the lines of the tops of the buildings and frame of the fence become a way to guide the gaze.

Background Lines

In the diagram on the left, I placed a person against a background that I drew using one point perspective. The person's head is positioned at the vanishing point, so the vanishing point's extending lines (perspective lines) act as a guide, meaning when the viewer looks at the picture, their gaze converges on that person's face. It will depend on the height of the person you are drawing (the one you want the gaze to converge on) as to how you apply this. This can include moving the camera view higher or lower, fudging the eye level, and using windows or low-lying lines instead of the tops of buildings.

Rather than placing elements at the vanishing point, another way of guiding the gaze is to place them on a line. However, as they are only on a line, it's possible the viewer's gaze will pass over the elements without pausing to observe them.

The background lines in the above figure can be said to work like "focus lines" often seen in manga. Concentration lines (shown to the left) are fine for manga or anime, but you might want to avoid using explicit concentration lines in illustrations. Start by naturally finding lines among the objects you're placing on the screen. Then, try to guide the viewer's gaze to the thing you want to stand out. There are countless lines within the frame.

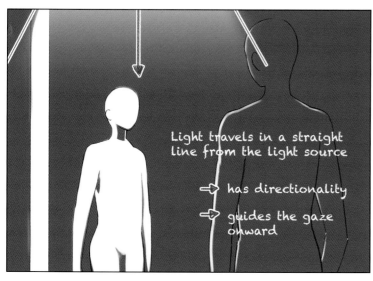

Light travels in a straight line from the light source

⇒ has directionality

⇒ guides the gaze onward

Directionality of Lighting

When a setting is dark, a person that has a street light shining on them will naturally stand out. But, in the case of the image to the left, the directionality of the lighting influences how the gaze is guided. It goes without saying that light travels straight out from its source. The light source in the diagram is directly over the person on the left, creating an invisible arrow pointing down onto that person. It functions similarly to the guidance of focus discussed on the facing page. People try to follow the path of light with their eyes, so incorporating this characteristic into gaze guidance can be effective.

Seeing those focus lines reminds me of a halo.

Be careful with what you say—you'll get bad karma!

Mastering Shadows

Shadows always exist, not only in pictures, but also in photographs, videos and everywhere in the real world. Although the word "shadow" is used here, we'll discuss two types of "shade." Both of these are essential elements for visual expression.

Two Types of Shadow

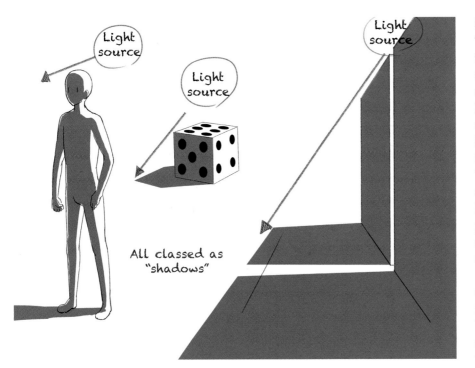

Shadows cast by light

This is a dark area created when the light source is obstructed by an object: a shadow. Light and shadow are linked together. The light source always needs to be considered when drawing shadows. Shadows play a significant role in the composition of a picture. They can be used to express the shape of an object blocking the light or to create tones in the picture. You could say that there are as many ways to use shadows as there are pictures.

Moreover, light and shadow are symbols of contrast. They represent positive and negative. You can create much more attractive pictures by including this meaning in your expression.

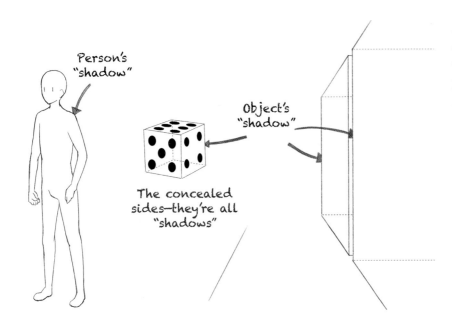

"Shadows" that obstruct vision

These "shadows" are otherwise known as "blind spots." They represent the unknown, and are commonly used in horror movies.

People are instinctively curious and/or apprehensive about areas that aren't visible to them. Intentionally creating areas that can't be seen can have a strong impact on the viewer.

How to Use Shadows

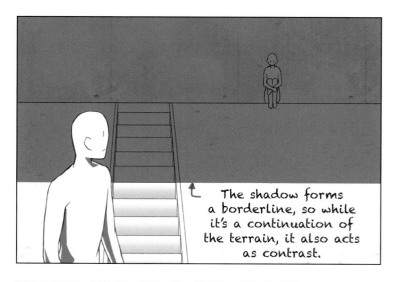

The shadow forms a borderline, so while it's a continuation of the terrain, it also acts as contrast.

First, we look at how to use shadows.
I created a shadow in the image on the left and placed a person sitting down within that shadow, while another is in an area of light. As mentioned above, this is a composition which includes a meaning of positive and negative.

The person taking a rest out of the sun may be facing a problem of some sort. The person in the sunlight may be moving around with vigor because they are in high spirits. There's a narrative formed just by the front figure looking toward the person in the back. What story did you infer from this?

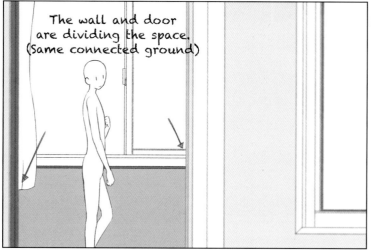

The wall and door are dividing the space. (Same connected ground)

Next, we have an image that shows the "shadow" known as a blind spot.
Between the wall and the door, there's a room or some kind of space, making the person in the background seem distant. What do you think is on the other side of this wall? I intentionally made an ambiguous space to leave room for the viewer's imagination.

Finally, I used shadows and blind spots together.
Two people can be seen hiding behind a pillar, concealing themselves from the shadow at the bottom of the picture.

If you view this as a rule-of-thirds composition, you'll see that the 4 framed areas to the upper left are darker. Even though there are a lot of bright areas, the shadows give the composition a sense of tension.

You may have also noticed that the outer frame of the picture both defines a blind spot and borders a mysterious emerging shadow. We can only imagine from the shape of the shadow what the third person is like. Using shadows and blind spots in this way can expand the range of expression in pictures.

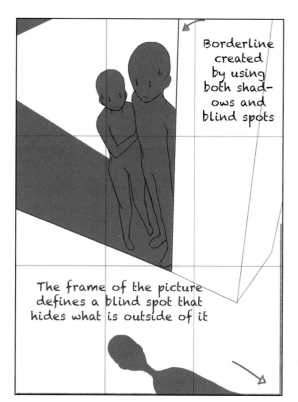

Borderline created by using both shadows and blind spots

The frame of the picture defines a blind spot that hides what is outside of it

Low-Angle and High-Angle Views Are Distinct from Composition

Explanations of compositions often talk about low angle and high angle views. The conclusion is that they are both terms for the angle of view. The angle of view is the angle from which the subject is being captured.

It is not really relevant when thinking about compositions where you are deciding the placement of elements and guiding the viewer's gaze. At most, they change the angle at which objects are seen, so it can be used as a basis for separating areas that can and can't be seen.

The image on the right shows a person drawn from a low angle, making it a simple portrait in terms of composition.

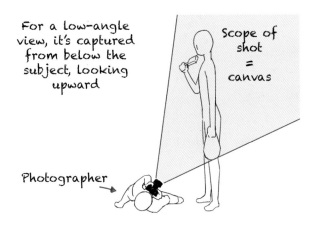

For a low-angle view, it's captured from below the subject, looking upward

Scope of shot = canvas

Photographer

In a rule-of-thirds composition, placing a character drawn from a low angle and including architectural elements as the background will also present the buildings from a low angle. It also means that the proportions within the picture depend on the arrangement of the elements and whether they are low-angle or high-angle. You can see here that the angle of view has no direct relationship with the composition itself.

Creating a Composition with a Camera

While illustrations differ from photographs, they are actually similar in terms of composition. So, a composition of an illustration can also be created from photographs. This is a technique that professionals use.

Even if you can draw in various ways, why not try out your camera for a fresh approach?

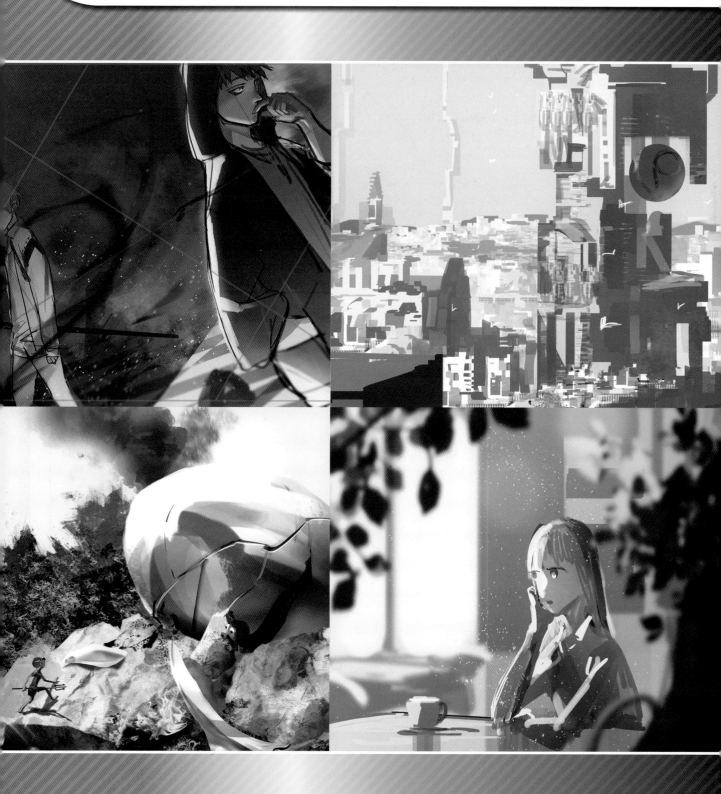

Make Rough Sketches Using Everyday Objects

Use your smartphone camera to lay the groundwork for the illustration.

1 Assembling Items for Photographing

What happens if you're just not able to draw a rough sketch? Here, we'll create a rough composition using items that can be bought from a dollar store, if they're not already on hand.

What I Prepared For This Shoot

Tissue Box
A tissue box or similar works well, and this type of long, narrow box can be used in many different ways. Try it as a guide for buildings and cars.

Wire Mesh
The horizontal and vertical wires of the mesh form a grid. This grid makes the position of items clear and is perfect for use to represent the ground. It helps you easily understand the perspective too.

Pitcher
Use this as a guide for tall buildings and large vehicles. The handle could also come in useful for something.

Marbles
Placing these around the composition will create a basis for directing the gaze and a reference for placing the elements in a way that increases the density of objects in the picture.

Ping-Pong Balls
Larger than the marbles, these can be used as a reference for an object that will stand out more.

Decorative Plants (2 Types)
Small plants can come in handy for various things. They can be used as a reference when thinking about the proportion of natural objects in a picture and also for "photobashing" (cutting and pasting photos into a composition).

Drawing Paper
This can be used in many ways, such as for creating raised ground or hiding distracting patterns. I recommend using a thicker type as it holds its shape better.

Drinking Glass
A glass is tall and stable, so the shape can be used as a reference for people or tall structures. It's also versatile, as it can be used upside-down too.

Square Accessory Container
This can form a basis for buildings and urban settings. You can also contrast it with the rectangular kitchen paper box.

2 | Let's Create a Standing Character

How do you actually create a rough sketch from a photograph? Here, I'll explain how, starting with the minimum compositional placements.

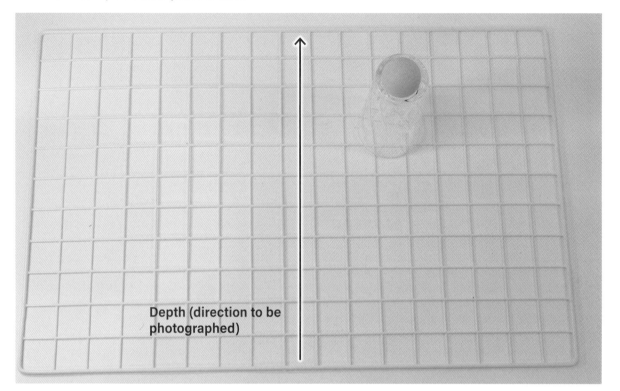

Depth (direction to be photographed)

Envisioning the placement and perspective of elements solely in your mind can be difficult. If you're not careful, the artwork might lack depth, making the world seem flat.

Start by laying down the wire mesh to act as a guide for depth perspective. Place items that will be a reference for the person (in this case, a glass and ping-pong ball).

The formation of a shadow makes it easier to understand the depth and creates an impression too

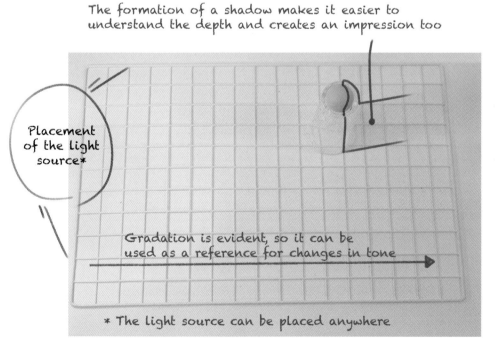

Placement of the light source*

Gradation is evident, so it can be used as a reference for changes in tone

* The light source can be placed anywhere

Applying Light

Having a nearby point light is better as it will reinforce the sense of depth. The lighting can change the appearance of the entire picture.

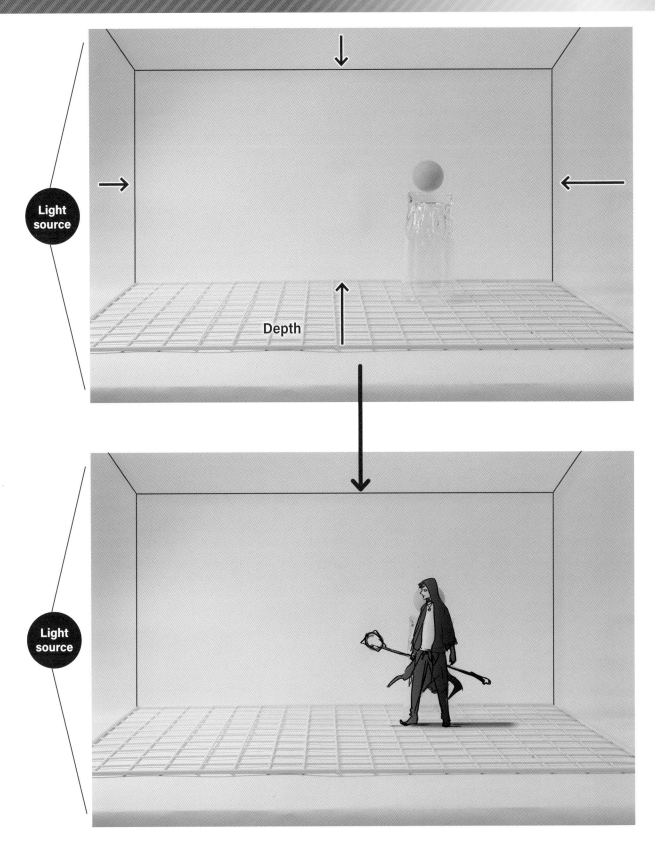

Light source

Depth

Light source

The layout on page 115 showed a perspective looking nearly straight down. The above is from a much lower perspective. The ground that had filled up the whole picture (field of view) is now compressed and a sense of depth has been created. When starting to draw an illustration from scratch, the blank, two-dimensional plane in front of you can make it difficult to grasp depth and distance, often making it tedious to compose the drawing.

However, in the case of a photograph, the placement and depth of objects are already set, clarifying the image. It's better to use real objects to grasp perspective and depth that are difficult to envision. Another advantage of this technique: if you dislike the angle, perspective or arrangement, you only need to change the camera's position or move the items.

3 Try Creating a More Complex Composition

There are two key points to keep in mind when taking photos that will act as a reference for a composition: 1) Aim to showcase the character in the illustration, and 2) Make the most effective use of the photo.

I have positioned the tissue box and the pitcher diagonally across from each other and put a glass in-between. I have also increased the density of the picture by adding ping-pong balls.

Regarding directing the viewer's focus, I've assumed that it will move from the glass (person) to the back and then around to the pitcher. My thinking is to place items of interest where the ping-pong balls are positioned.

When you look at this from a 3D perspective, it's really easy to understand how the gaze is guided, right? It's like the Z axis has been visualized on a grid.

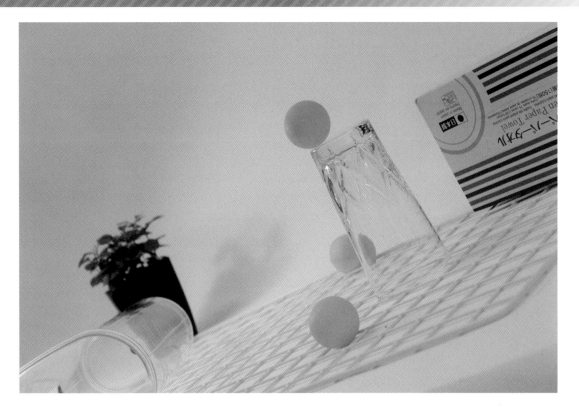

I experimented with difficult-to-draw compositions, such as having the horizon line at an angle. With photos, retakes are simple, whereas with illustrations, a new draft is needed every time you change the angle.

Be adventurous with the camera work. You can choose an image that has a unique slice of reality that only a camera can capture.

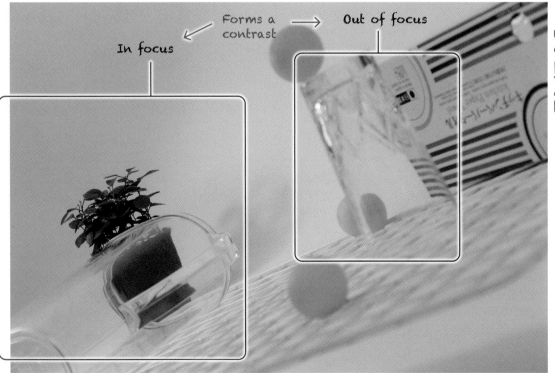

In focus

Forms a contrast →

Out of focus

Box that was originally planned to represent an object in the background

Initially, the intention was to have the character (symbolized by the glass) as the only individual pictured, and then draw a background that had a sense of depth. However, I felt it was more interesting to bring the plant in the far background into focus. So I decided to draw another character there and depict the relationship between the two people.

I decided there was no need for a detailed background. But, in case it was necessary to draw a background at the final stage, I left the box in place to serve as a reference.

First, I wanted attention to focus on the person at the back. So, I drew him larger than the plant in the photo. I've drawn the person in the foreground and enlarged him accordingly. And by cropping the figure at the top and bottom, it reduces his impact and implies that the person in the background is the main character. During the process, I decided that I don't want to show the ground extensively, so I've trimmed it. I then completed the sketch by adjusting the lighting and poses.

If It Looks Good, Draw Reference Lines

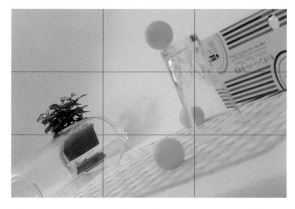

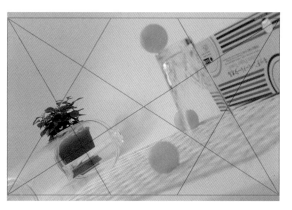

The glass is positioned on the top right point of intersection. The plant on the left fits within a frame.

The glass and the plant are both on lines perpendicular to the red diagonal line.

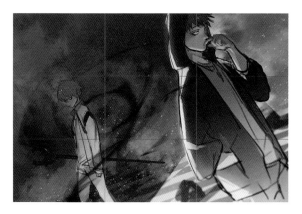

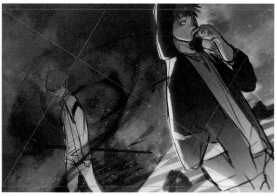

The person in the background fits within the two bottom left frames and the individual in the foreground is along the right-side reference line, creating an interesting composition without

any sense of irregularity. By chance, cropping the picture actually moved the person in the foreground into a more attractive position.

(Commentary: Studio Hard Deluxe)

4 Creating a Telephoto Effect Using Techniques to Place and Arrange Elements

When drawing large scale objects, photos can be a very useful reference. And there's no need to buy an expensive SLR camera or telephoto lens.

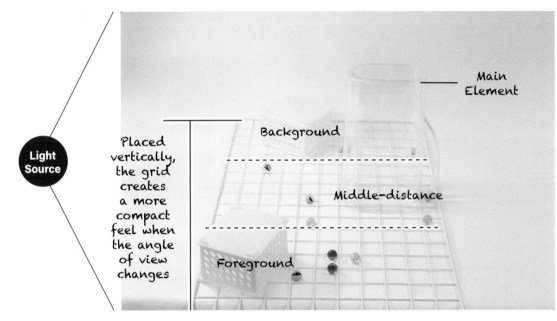

Light Source

Main Element

Background

Placed vertically, the grid creates a more compact feel when the angle of view changes

Middle-distance

Foreground

If you are drawing something on a large scale, it's impossible to avoid depicting a sense of scale and space. I placed objects in each of the areas for the foreground, middle distance and background to make it easier to express the space. To emphasize the size of the vertically-long motif that was the main element, I chose to make the other motifs smaller.

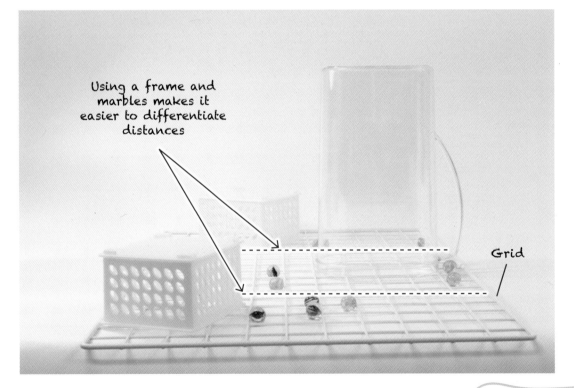

Using a frame and marbles makes it easier to differentiate distances

Grid

Changing the angle leads to deformation of the grid appearance, making it look more compact. If you place the elements vertically, you will get a more compact arrangement. This is the same effect as the depth observed in a photo taken with a telephoto lens.

Learn the principles of telephoto lenses and focal lengths by reading a book on photography.

Shadow

Shadow

Shadow

I made the town buildings comparatively smaller. This contrast causes the scale of the massive structure to stand out.

In order to make the main vertical element look bigger, I needed to decide the smallest units to which it would be compared. That boiled down to the buildings that covered the ground, forming a sprawling town. Then, to create depth in the picture, I progressively reduced the contrast of the town buildings as they recede into the distance. At this stage, I made the low-lying architecture as bright as possible. This makes it easier to draw the shadows cast by the larger buildings.

Referring to the photo that forms the basis for this composition, shadow is being cast on the ground to the right of the 3 motifs. I focused on representing this while drawing them. The positional relationships of the structures receding into the distance are clear. The shadows are drawn so that they form 90° L-shapes along the side of the buildings and down onto the town.

5 Using Part of the Photo Itself to Draw a Rough Sketch

Because I was going to the trouble of taking the photos myself, I decided to take a shortcut. I opted to use parts of the photo as-is when composing the rough sketch on my computer.

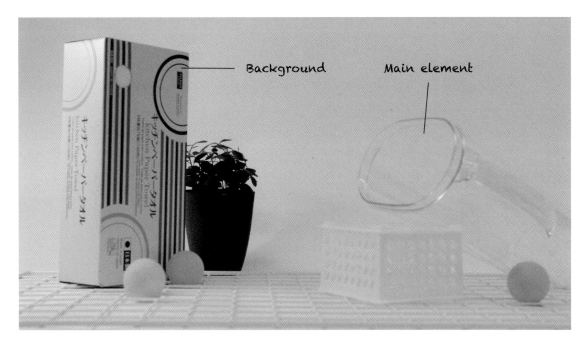

I started by deciding the main element and background. First, I created shadows using a box and plant, to signify the depth. This time, the ping-pong balls are a reference for guiding the viewer's gaze. I thought to make the main element a large structure, so I approximated a physical mass using containers. The pitcher itself is the main element's structure. At this point, there is still an empty area in the center, and not enough density.

Here, we're at the stage of checking the overall perspective. I'm looking at the depth and contrast. At this angle, it might look better after cropping. But for now, it's just for checking.

This is like a bird's-eye view—not the same as the angle of view for the composition he wants to draw.

If the ground is just represented by the accessory container rising above the grid, it will appear too abrupt. To solve this, I tried placing some drawing paper and a glass. This brought it a lot closer to the terrain I was after.

But it doesn't have quite enough impact. I would be drawing a gentle slope, so it would become just a regular hill. The box in the background is too high, making it seem overpowering.

Time to check the whole composition. Looked at front-on, the edge of the drawing paper runs up to the edge of the pitcher. From an overhead angle, they are completely separated. The placement of the cup isn't bad, but there is a lot more information on the left side than on the right.

This is different than the previous example. The placement and appearance of the elements create a completely different impression. This looks a bit harder to draw...

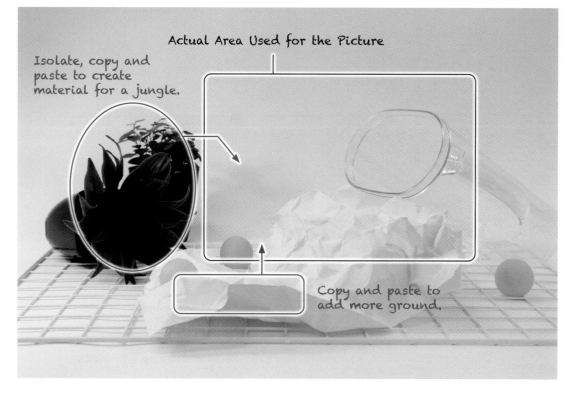

Actual Area Used for the Picture

Isolate, copy and paste to create material for a jungle.

Copy and paste to add more ground.

This assumes that you are creating the drawing using photo-editing software. I used elements of my photo to help flesh out my sketch. I crumpled up and formed the drawing paper to create a good rippled texture, and then built up a composition to look as if it featured undulating, rocky ground.

I wanted to have an organic, jungle-like background, so I removed the obtrusive box and placed actual plants.

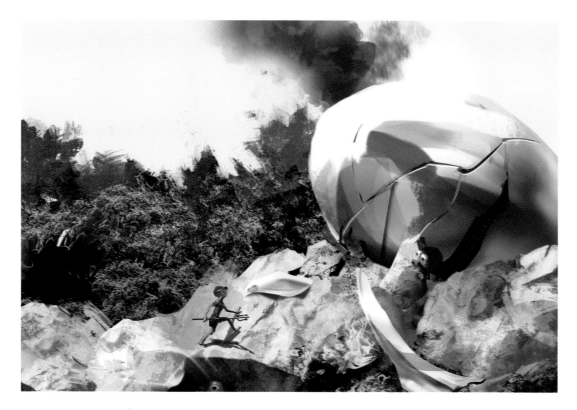

I processed the photo and filled in the picture. Photos have a large amount of information, so the look of the picture can be quickly improved just through simple copy-paste operations. I established the setting and story. I gave the large structure a unique look by turning it into a spaceship that had crash-landed.

This created contrast to the natural surroundings. I strengthened the storyline by adding the elements of a human boy and an alien hiding itself.

6 | Creating a Composition That Highlights a Character

Here, we'll sketch a picture with a person as the main element, similar to a scene from a movie. My aim is to create an image that quietly draws the attention without being too showy.

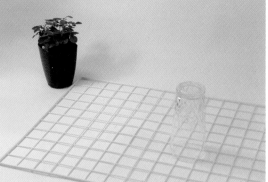

First, I placed the glass to represent the main element. I tilted the camera angle. It has the impression of being a portrait because there is nothing else in the picture.

This time, I put a plant across from the person. This is sparse for a background element, so I can't create a rough sketch with just this. I tried taking a photo from the same angle as before.

The glass is in focus, meaning the person can be emphasized. Regarding the positional relationship, the plant in the background resonates with the form of the main element, so I can draw a picture like the one on page 119. But I would like to fill the picture with a few more elements.

This is different from step 3 "Try Creating a More Complex Composition." This is because the elements have been added one by one. A lot of elements were removed in the rough sketch on page 119, but here there doesn't appear to be anything that can be taken out.

That other picture came together by chance. Here, right from the start, the aim was to make the person stand out, so the approach is different.

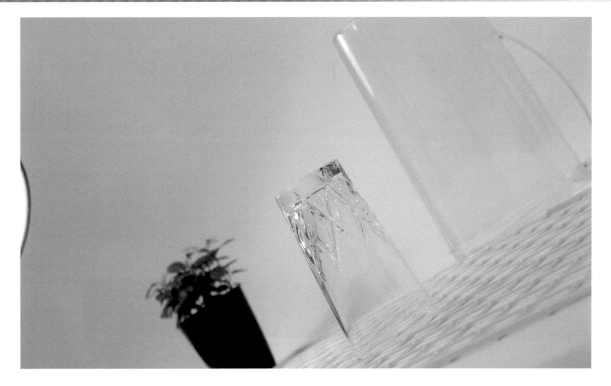

I tried placing the pitcher upside down. But, instead of highlighting the person, it seemed to enhance the background instead. So I gave up on this angle and composition.

What!? Everything's out!?

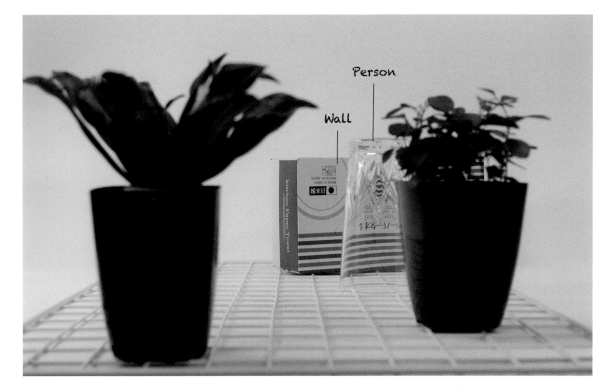

Person

Wall

I created density by placing a glass at the back and dark, out-of-focus obstructive items in the foreground. I envisioned it as a person visible through a gap. Behind the person, I set up a wall to create a contrast with the person, who illuminated by sunlight.

It really has completely changed... But if you're feeling your work is not quite right, then go right ahead and change the whole thing!

On my computer, I checked the photo I'd taken. I started cropping boldly. I cut quite a bit of the unnecessary material at the top and bottom.

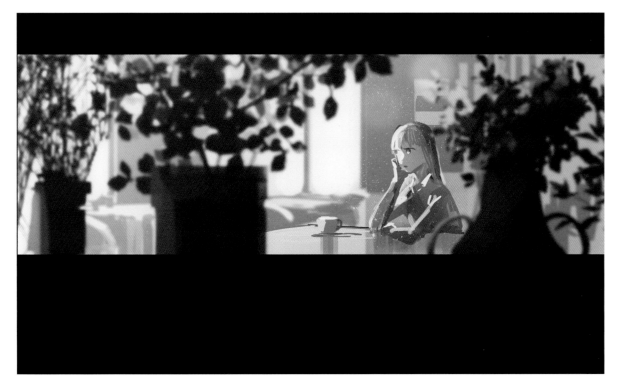

Dark, out-of-focus potted plants are in the foreground and the background is bright, with light streaming in from the side. I moved the position of the person a little from the center to the right. I worked on the background next. The frame is long and narrow with strong horizontal lines, so adding another horizontal line would look monotonous.

I set the vanishing point on the right of the picture to create a background with depth. In order to draw the gaze even more toward the person, I made the shadows darker. This created contrast, which naturally guides the gaze. In this picture, it was important for only the area around the person to be in focus.

Published by Tuttle Publishing, an imprint of
Periplus Editions (HK) Ltd.

www.tuttlepublishing.com

ISBN 978-4-8053-1792-1

ILLUST KOZU KANZEN MASTER
Copyright © Rui Tomono, STUDIO HARD DELUXE
2017
Copyright © GENKOSHA Co., Ltd. 2017
English translation rights arranged with GENKOSHA
Co., Ltd. through Japan UNI Agency, Inc., Tokyo

English translation © 2024 Periplus Editions (HK) Ltd
Translated from Japanese by Wendy Uchimura

Distributed by:

North America, Latin America & Europe
Tuttle Publishing
364 Innovation Drive
North Clarendon
VT 05759-9436 U.S.A.
Tel: (802) 773-8930; Fax: (802) 773-6993
info@tuttlepublishing.com; www.tuttlepublishing.com

Japan
Tuttle Publishing
Yaekari Building 3rd Floor
5-4-12 Osaki Shinagawa-ku
Tokyo 141 0032
Tel: (81) 3 5437-0171; Fax: (81) 3 5437-0755
sales@tuttle.co.jp; www.tuttle.co.jp

Asia Pacific
Berkeley Books Pte. Ltd.
3 Kallang Sector, #04-01
Singapore 349278
Tel: (65) 6741-2178; Fax: (65) 6741-2179
inquiries@periplus.com.sg; www.tuttlepublishing.com

Printed in Singapore 2311TP

28 27 26 25 24 23
10 9 8 7 6 5 4 3 2 1

"Books to Span the East and West"

Tuttle Publishing was founded in 1832 in the
small New England town of Rutland, Vermont
[USA]. Our core values remain as strong today
as they were then—to publish best-in-class
books which bring people together one page
at a time. In 1948, we established a publishing
outpost in Japan—and Tuttle is now a leader in
publishing English-language books about the
arts, languages and cultures of Asia. The
world has become a much smaller place today
and Asia's economic and cultural influence has
grown. Yet the need for meaningful dialogue
and information about this diverse region
has never been greater. Over the past seven
decades, Tuttle has published thousands of
books on subjects ranging from martial arts
and paper crafts to language learning and
literature—and our talented authors, illustrators,
designers and photographers have won many
prestigious awards. We welcome you to
explore the wealth of information available
on Asia at **www.tuttlepublishing.com**.

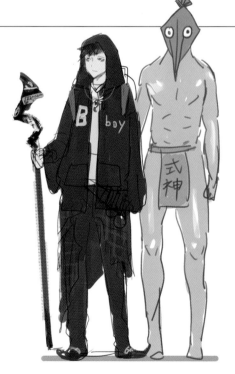